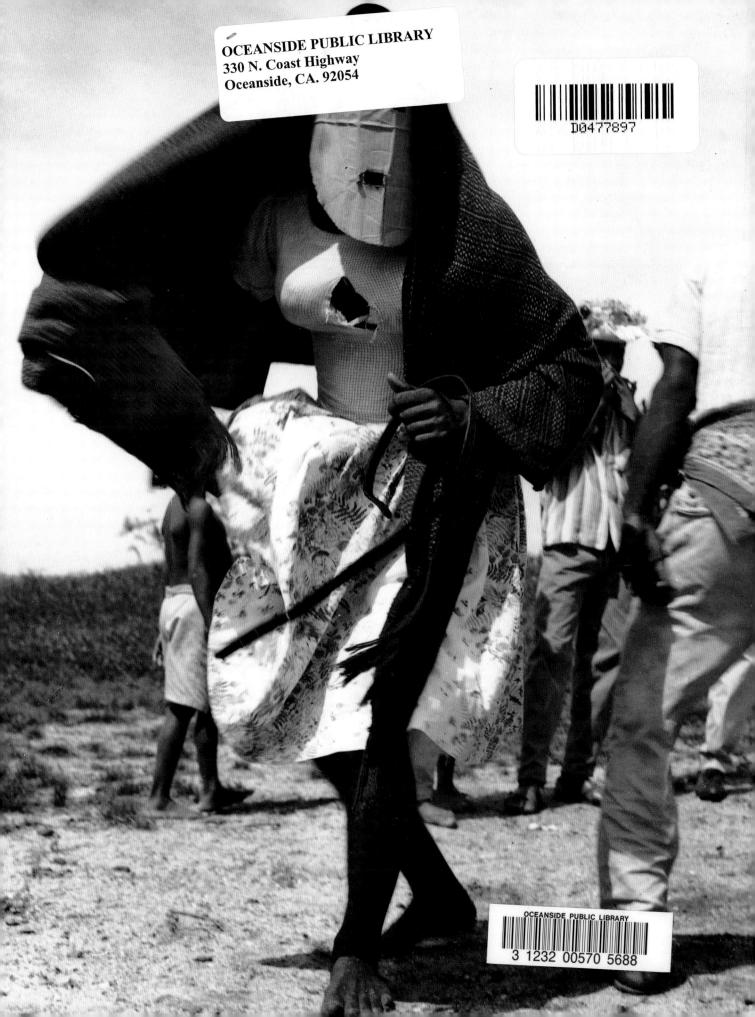

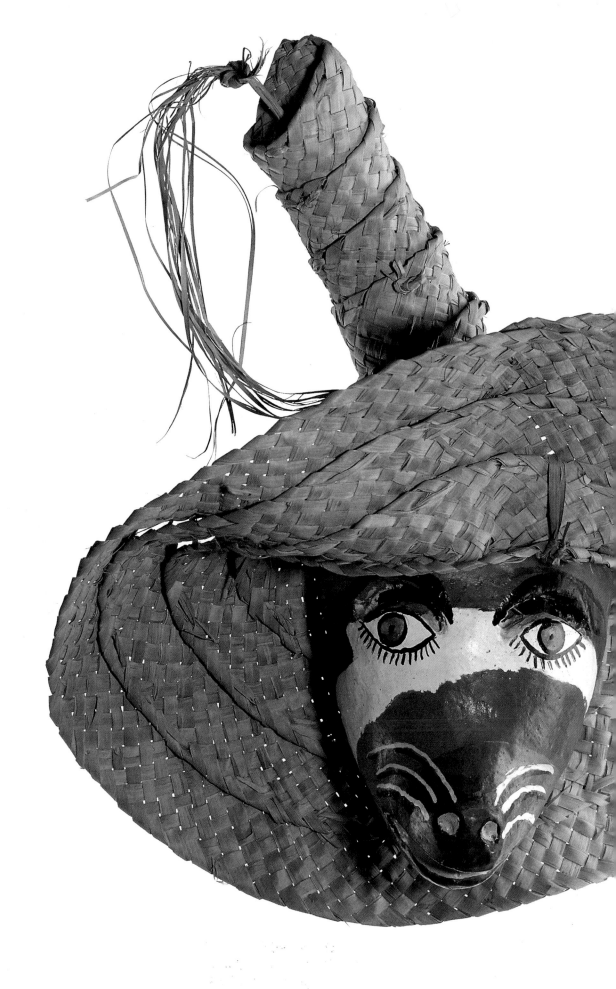

MASK
ARTS OF
MEXICO

Ruth D. Lechuga
Chloë Sayer

Photographs by
David Lavender

CHRONICLE BOOKS
SAN FRANCISCO

CONTENTS

Half-title page
Male dancer wearing female clothing during *la danza de los diablos* (Devils). This dance is performed during Day of the Dead ceremonies in La Estancia Grande, Oaxaca; inhabitants are of Black African descent. Mask and bust have been improvised with flexible cardboard.

First published in the United States in 1995 by Chronicle Books.

Copyright © 1994
by Chloë Sayer and Ruth D. Lechuga

Printed in Singapore

Library of Congress Cataloging-in-Publication Data available

ISBN 0–8118–0811–4

Distributed in Canada by
Raincoast Books
112 East Third Avenue
Vancouver, B.C. V5T 1C8

10 9 8 7 6 5 4 3 2 1

Chronicle Books
275 Fifth Street
San Francisco, CA 94103

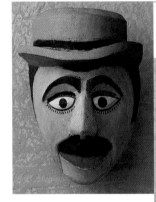
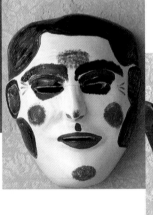
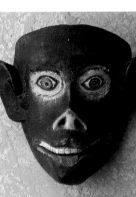

19,50

4

5

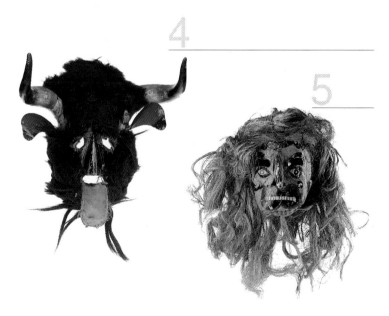

Preface

I would like to dedicate this work to the memory of my father, who died in 1991 at the age of ninety-six. It was he who first taught me to appreciate the landscapes and archaeological sites of Mexico. Lucid until the last day of his life, he loved all aspects of Mexican art, past and present.

I am grateful to Chloë Sayer whose dedication has made this project a reality. I also thank David Lavender for his beautiful photographs. Other investigators have shared my enthusiasm for the world of masks, and I am indebted to them for so generously imparting their discoveries and data. They are Sra María Teresa Pomar and Sr Bernardo Pérez of Mexico City; also Dr Janet Brody Esser of San Diego, California. Many other people – friends, mask-makers and dancers – have provided valuable information that has aided my understanding and interpretation of masks and their uses. Although it would be impossible to name them all individually, I express my heartfelt thanks.

The masks shown in this book have been chosen from my own personal collection. I shall always be grateful to the following, who have worked tirelessly to preserve and to make known this marvellous branch of Mexican popular art: Sra Sandra D. Angevine, Dr Judith Deutsch de Stern, Sr and Sra Barbara and Enrique Franco, Sra Irene Herner, the anthropologist Jorge Miranda, Sr Hector Adrián Toledano, and the anthropologist Marta Turok.

There are many different motivations for collecting masks. Some people simply perceive masks as agreeable objects which they can use to adorn the walls of their homes; often complicated in style, their chosen masks may be wholly decorative and never employed during dances. Other collectors, by contrast, value their masks in accordance with their antiquity, and purchase only those masks that have actually been worn by dancers.

When forming my own collection, however, I have tried to encompass as wide a range of masks as possible: not only do they originate in different regions and represent a large number of indigenous groups; they also represent an astonishing variety of dances and stylistic forms. I have collected some very old masks. (A small number were probably made in the eighteenth century.) But I have also bought a great many new masks directly from their makers. As a result my collection reflects the changes that have happened over periods of time, and allows one to appreciate the enormous diversity of expression. I have not sought to form a valuable collection of objects from the past; my aim has been the creation of a collection for study. I now invite the readers of this book to embark on a great adventure and discover the meanings underlying Mexico's mask tradition.

RUTH D. LECHUGA

The Traditional Dance-Masks of Mexico

A mask is an artificial face: positioned over a real face, it transforms the wearer. In Mexico beings of all types are represented by means of the mask. These include human beings, both male and female; creatures from the animal kingdom; and supernatural beings that embody religious concepts and exist only in the imagination. Some masks fantastically combine elements from different categories, and may even serve as reminders of ancient deities from the pre-Hispanic world. Wherever masks exist and whatever their genre, they seem to outstare the onlooker with a fixed and unchanging gaze.

Many human masks are extremely realistic in style and faithfully reproduce different facial types; others, by contrast, are so highly stylized that facial features are merely suggested. While some mask-makers finely texture surfaces, relying on special procedures to imitate the smoothness and exact shading of the human skin, others apply a minimum of detail. Regardless of finish, however, masks must convey the essential characteristics of the human being portrayed. They may evoke ambition, violence, virtue, wisdom, simplicity or plain stupidity. Masks can inspire sympathy or terror; while some are serious, others are smiling, comic or verging on caricature.

Since approximately 2000 BC, many distinctive and highly developed civilizations have existed in Mexico. Substantial archaeological remains were left by the Olmec, by pre-Classic cultures on the central plateau, by the inhabitants of Teotihuacán, by the Zapotec, the Mixtec, the Maya, the Toltec, the Totonac, the Aztec (or Mexica), and by such peoples as the Tarascans (or Purépecha) of Michoacán. Although

excavations have yielded masks dating from c. 1000 BC, their use probably evolved at a far earlier period. In the pre-Hispanic world masks habitually covered the faces of deities, priests and those who were sacrificed to the gods, while the elaborate costumes of warriors often incorporated a mask. Examples carved from stone or incrusted with a fine mosaic of turquoise and other semi-precious stones were placed in the graves of the high-ranking dead or attached to mortuary bundles in regions where cremation was current.

Masks played an important role in Tenochtitlan, the capital of the Aztec empire. Archaeologists have found numerous examples embedded in the construction of the Templo Mayor (Great Temple). According to Spanish writings of the Conquest period, these were positioned there as offerings to the gods. Nevertheless, masks were most often employed during a wide range of dances. Spanish sources confirm that special dances were dedicated by the Aztec to specific gods. Groups of young men and women received professional training as dancers, but some dances demanded the participation of the emperor himself, together with that of nobles, priests and the humblest of citizens. Spanish chroniclers such as Fray Bernardino de Sahagún and Fray Diego Durán referred to various disguises: participants performed as Old Men, Hunters and Wild Men; while some would pretend to sleep, others would give out provisions to spectators. Often, dancers would adopt the clothing of other races. Zoomorphic masks were frequently worn: dancers impersonated jaguars, monkeys, dogs, eagles and different birds, bees, sea creatures and many others animals.

In 1521 the Spaniards conquered México-Tenochtitlan (now Mexico City) and imposed their own culture. They, too, employed masks during the many dances that they introduced into the New World. Determined to promote the Catholic faith, crusading friars harnessed the indigenous fondness for masked spectacles and dances by utilizing short plays as a method of conversion: enacted by the Indians themselves, these would recount Biblical events. With the passing of time, a new range of dances evolved in Mexico. Despite the widespread adoption of Christianity, however, many ancient beliefs were retained: the result has been a syncretism that persists even today, while the masking tradition – central to Old and New World cultures – is still practised in most regions of contemporary Mexico. Made and worn by Indians as well as Mestizos (Mexicans of mixed European and Indian descent), masks are required for dances and for ceremonial occasions such as *Carnaval*, Holy Week, or the Days of the Dead (1 and 2 November) when the living welcome the souls of the departed during their brief return to earth.

Mexican dances encompass many elements. Music, choreography (which often relies on highly complicated dance-steps), costume and masks help dancers to assume the characteristics of their adopted roles. As theatrical events, dances adhere to a narrative structure. Performers communicate the storyline through the exchange of words, or through choreographed dance-steps, gestures and sign language; often they convey as wide a range of actions and emotions as actors do in the formal theatre. Although masks have fixed expressions if seen in isolation, they can appear surprisingly animated when worn. The dynamism of certain faces may even be increased by cunning devices. In the state of Tlaxcala, for example, some masks are fitted with a

hidden spring: by pulling a cord, dancers can cause the eyelids to open and close (**17, 36**). Movable tongues and lower jaws, activated when the wearer moves his own tongue, are sometimes found in the states of Mexico and Guerrero (**27, 28, 119**).

Most masks are scaled to fit the human face. Usually dancers look through narrow slits above the painted eyes of the mask; occasionally, however, the expressiveness of a face is dramatically enhanced when the sight-holes are so positioned that the wearer's own pupils become the eyes of the mask. In a few communities where masks are abnormally large, the dancer's line of sight is through the open mouth (**81**). Alternatively, eye-slits may be positioned beneath the painted eyes. Some masks, by contrast, are so small that they barely cover the wearer's eyes and nose (**24**). The scale of masks affects a dancer's overall appearance. As may be imagined, a minuscule face will tend to make a performer seem taller than he really is, a huge one exaggerates the wearer's size.

Although masks reflect the dominant characteristics of a specific role, there are important geographical differences. A *negro* (Blackman) from the state of Veracruz does not in the least resemble a *negro* from the state of Oaxaca. Representations can also vary within a given region; this is evident on the Tarascan *meseta* (highland area) of Michoacán, where stylistic interpretations change from one village to the next. Account must also be taken of the creativity of individual craftsmen: although mask-makers operate according to local tradition, the work of each is nevertheless unique.

The physiognomy of masks can also evolve over time, as is shown by the *tastoanes* of central Jalisco (**128, 129**). Made from leather, these impressive masks were formerly painted with scorpions and other creatures. Gradually their appearance became more terrifying; using plaster, makers began

to add hooked noses and to superimpose malevolent creatures of various kinds. Now the noses are of wood, while the leather faces are painted with bikini-clad women and other contemporary images. The resulting effect is more comic than frightening.

In *La Voie des Masques*, Claude Lévi-Strauss states: 'Masks, like myths, cannot be interpreted on their own and in their own right, as if they were isolated objects.' Rather, masks should be studied in context: for their role to be understood, the dances themselves need to be analysed and their meaning examined. There is an enormous number of dances in Mexico – so many, indeed, that one person cannot know them all. It is possible, however, to establish general categories for dances that originated around the same period and share certain themes. Because Mexico's fifty-six indigenous peoples retain different cultural traits and speak fifty-six languages, the names and interpretations that apply to a single theme can vary widely.

Before the Conquest many dances had a cosmic significance relating to the four cardinal points and the passage of the sun. According to pre-Hispanic beliefs, the vertical world was divided into heavens and underworlds. All these levels were connected by the *axis mundi* – the fifth direction, or central pole. Every twenty-four hours the sun completed its journey, illuminating the earth by day and the underworld by night. Today, a few dances still reflect the cosmology of ancient civilizations. These include *el palo volador* (Flying Pole), which requires performers to 'fly' from a tall pole by launching themselves into space, *los quetzales* (Quetzal Birds) and *los acatlaxquis* (Reed Throwers); masks are not worn.

Dances featuring *viejos* or *viejitos* (Old Men or Little Old Men) were also described in the writings of Spanish chroniclers. Within indigenous cultures, old people are treated with enormous respect; during their lifetime they may have occupied important positions within the community; now, in old age, their wisdom benefits that community. The most highly valued authority in each village is the council of elders: together, they shape the destiny of the inhabitants. The term *viejo* is also applied to ancestors: revered and feared, they watch over the living from the next world and observe their behaviour.

In pre-Hispanic Mexico the word *viejo* was additionally used to describe Huehuetéotl, god of fire, referred to by the Aztec as the 'Old, Old Deity' and the 'Lord of the Year'. Huehuetéotl's feast was held at the end of the year, and the month was marked by ceremonies to ensure the continuation of life. Fires were extinguished in all hearths. Only when the new fire had been lit on a nearby hill-top could the Aztec rejoice: the world had been saved for a further year. Today in Indian Mexico this same symbolism underlies some of the different rituals of Holy Week. Although *viejos* perform in many regions and on many occasions, their masks do not always suggest advanced age; the *viejitos* of the Tarascan *meseta*, for example, exhibit surprisingly youthful faces.

Ceremonial buffoons appear in a large number of dances; they are marginal characters who participate in the proceedings, but whose role is not an integral part of the storyline. For this reason, they are often termed *viejos separados* (Unaffiliated Old Men). There are many indications that they belong to pre-Conquest tradition. Ceremonial buffoons usually perform singly or as a pair, and dress differently from other performers. They are responsible for keeping a clear space for the dance; they joke with onlookers, flirt with female bystanders and frighten children. Some dances are entirely peopled by buffoons, who mock the serious dances that are simultaneously taking place.

Also of pre-Hispanic origin are dances featuring animals, although today the animals

are not always indigenous. Goats, sheep, bulls, cats, pigs and roosters are just a few of the many creatures introduced into Mexico after the Conquest. Some dances depend on a single species; others require the participation of several different creatures. The most important animal of all is the jaguar, today generally termed *tigre*. His behaviour varies from dance to dance, but his presence is often related to agriculture and the harvest.

The first Spanish dance to be performed in the New World was that of *moros y cristianos* (Moors and Christians). The Moors had been driven out of Spain as recently as 1492. According to the chronicler Bernal Díaz del Castillo, Spanish festivities of the Conquest period always included *emboscadas de cristianos y moros* (ambushes by Christians and Moors). Proselytizing friars enthusiastically promoted this dance in Mexico, because it taught indigenous peoples about the superiority of Christians. A key role was always given to *Santiago* (St James), divine protector of Spaniards. The dance of *moros y cristianos* was rapidly adopted by Indians and performed in a range of native languages. Today many versions of this dance exist. In some, all the performers are masked in accordance with their different identities, while in others masks are worn by one group only. Alternatively, no one is masked. In regions where masks are used, styles of representation can change from village to village; highly variable also are the names of characters. The theme is not always the reconquest of Spain; some variants portray the crusades, while others are set at the time of the conquest of Jerusalem. One version, entitled *los doce pares de Francia* (Twelve Peers of France), depicts the battle waged by Charlemagne, king of the Franks, against the Moors.

In the New World the cycle of *moros y cristianos* soon gave rise to a further range of dances recounting the Spanish victory over the Indians and their eventual conversion to Christianity. *Conquista* (Conquest) dances take several forms in contemporary Mexico. Sometimes Hernán Cortés himself appears, accompanied by *la Malinche* (his interpreter and mistress) and by a host of other historical characters. In many dances, however, the Indians wear fine costumes with magnificent headdresses of plumes or coloured paper, while the Christians are played by children who sometimes dress in the guise of modern soldiers. There are also versions peopled only by the Indians: these dances are termed *media conquista* (half-Conquest).

During the first years of contact, Spanish missionaries instigated a further cycle of dances based on mystery plays and allegorical dramas. Having perceived the native fondness for theatrical representations, the friars composed short works inspired by the Catholic religion to be enacted by the Indians themselves. From the Conquest period to the present time, the inhabitants of Mexico have regularly performed *pastorelas* (Christmas dance-dramas with shepherds), dances featuring St Michael, *los siete vicios* (Seven Vices), *las tres potencias* (Three Powers), *los mudos* (Mute Ones), *los diablos* (Devils), *las pastorcitas* (Little Shepherdesses) and song-cycles in honour of the Jesus Child. The masks worn during these dances are often remarkably fine and extremely diverse.

Catholic friars also introduced their new converts to the pre-Lenten festival of *Carnaval* and to Holy Week. The Indians interpreted these events in their own way, however, investing them with a meaning that reflected a marked syncretism with pre-Hispanic ceremonies. The Aztec year had started on 2 February – a date similar to that of *Carnaval*. Dedicated by the Aztec to the Tlaloques (rain gods), the first month of the

year saw the initiation of the agricultural cycle, when farmers habitually prepared the land for planting. This important time was characterized by rites of purification through water or fire. After the Conquest these ceremonies transferred themselves to *Carnaval*: today, requests for rain and other symbolic practices relating to the fertility of the earth are frequent and take many different forms. Purification rites can be seen during *Carnaval* among the Tzotzil of San Juan Chamula; here celebrants run along an avenue of burning *zacate* (straw). We know from Bishop Diego de Landa, the sixteenth-century chronicler, that this ritual was current among the pre-Conquest Maya. In modern Mexico, *Carnaval* serves another important purpose: it enables dancers to mock and parody their ancestral oppressors. Using the festival as a pretext, performers delight in rendering ridiculous landowners and *hacendados*, priests, arrogant city-dwellers and even their fellow-villagers. In other regions, however, *Carnaval* is merely a time for having fun: it is enjoyed each year as an occasion for revelry, disguise, dancing and burlesque.

During Holy Week, the betrayal and death of Jesus Christ are dramatized in accordance with the teachings of sixteenth-century friars. The story of the Passion is acted out, scene by scene, by the faithful who are often masked. Judas and Pontius Pilate are each represented by one or more performers. Hugely outnumbering them, however, are Christ's persecutors, who sometimes turn out in their hundreds. They are variously termed *judíos* (Jews), *fariséos* (Pharisees), *romanos* (Romans) or *diablos* (Devils). The word '*judío*', it should be clearly stated, is used by indigenous peoples to describe someone who pursued and brought about the death of Christ; it does not refer to real people. Antisemitism probably clouded the judgment of many Catholic missionaries who

communicated the events of Holy Week to the New World: at the time of the Conquest, Spain was preoccupied with the expulsion of the Jews and with the persecution of false converts by the Inquisition. But today the actors who perform as *judíos* are only playing a role. As Janet Brody Esser notes in *Behind the Mask in Mexico*, 'Ironically, few of the participants have ever met or are aware of having met anyone who is Jewish.'

In reality, the true significance of Holy Week for many unacculturated peoples is the cosmic struggle for life on earth. The *judíos* symbolize the nocturnal forces that kill the sun as represented by Christ. His ascent to heaven on Easter Saturday, known in Mexico as *el Sabado de Gloria* (Saturday of Glory), is thought to guarantee another year of life for the human race. This moment is marked by general rejoicing: groups of dancers pay homage to the new sun, requests for a good harvest are represented by flowers and plants, and purification rites are undergone. Cora, Yaqui and Mayo *judíos* actually destroy their masks. The Cora wash in the river and allow the current to carry away their masks of papier mâché (**73, 111, 130, 131**). The Yaqui and the Mayo build a huge bonfire and burn their helmet-like masks, thereby achieving purification through fire (**57, 127**). These rituals underline the ceremonial importance of masks in traditional cultures. Within the three groups just mentioned, young men who participate in the *judéa* (association of *judíos*) are undergoing a rite of passage from adolescence to adulthood.

Black Africans were introduced into the New World by the *conquistadores*. An illustration from the sixteenth-century *Atlas* of Fray Diego Durán shows an African in the retinue of Cortés as he goes to meet a group of Indian dignitaries. Dances featuring *negros* (Blackmen) or *negritos* (Little Blackmen) were born of the curiosity they aroused. Mexico's indigenous inhabitants found black

settlers no less strange than Europeans, so observed them carefully. During the colonial period black people had a wide range of occupations, and this is reflected in the dances. As with *judíos*, however, no racial discrimination was intended. Although the fusion of black, white and Indian gave rise eventually to the modern Mexican nation, it is still possible to find masks with the physiognomy of each racial type.

As has been mentioned, agriculture is associated with several *tigre* dances and with others performed during *Carnaval* and Holy Week. Agricultural themes also dominate *los tlacololeros*, which shows farmers planting maize on the mountainside. During *la fiesta de los locos* (Festival of the 'Crazies'), the inhabitants of Metepec in the state of Mexico used to equip teams of oxen with immense pictures made from seeds: these depicted the miraculous life of *San Isidro labrador* (Saint Isidore the Farmer). So devout was this saint that he passed his days in prayer while angels guided his plough and watched over his crops. Today ox-drawn ploughs have been replaced by tractors, and festivities have been modernized. Seed-pictures of the saint are now displayed on tractors.

As new dances evolve, the existing repertoire is constantly expanding. Often, historical events are dramatized. These include Mexico's battle for Independence, won in 1821 after long years of struggle, and invasion by French forces during the 1860s. Bygone customs are commemorated by countless dances. Some show life on the great *haciendas* of the nineteenth century. *La danza de los vaqueros* was inspired by Mexican cowboys, while *la danza de los arrieros* reflects the life of the muleteers who once transported goods from coast to coast.

These dances and popular dramas are not performed by professional actors. Their survival depends on the commitment of villagers and town-dwellers, who support themselves and their families with a wide range of different occupations. Dancers, who work throughout the year as blacksmiths, bus- and truck-drivers, plumbers, bakers or – more usually – farmers, perform for a variety of reasons. Some promise to dance for a specific number of years if a particular desire is granted. Although this desire may be of a personal nature, it frequently concerns the community at large: dancers may wish for a good harvest, for the completion of an important public work such as a road, or for good health and freedom from epidemics. Other dancers make a vow, termed a *manda*: if an individual's wish is granted, he is under divine obligation to perform for a certain number of years.

Dreams play an important role in Yaqui communities: those destined to be *pascola* dancers have their future duty revealed to them in sleep. The *pascola* (Old Man of the Feast) is the ritual host during all Yaqui festivities. His obligation is for life: whoever disobeys the divine command will be punished by death-inducing illness. During Holy Week within Cora, Mayo and Yaqui cultures, all young men are required to come out as *judíos*, or *fariséos*, for a minimum of three years. Only thus can they earn social acceptance as men. In many regions, however, dancers are motivated by enjoyment and by a sense of community. Not only do they take great pleasure in performing; they are simultaneously displaying their allegiance to their town or village. In the state of Tlaxcala and in a few other places where participation is voluntary, each dancer visits the *presidencia municipal* (seat of local government) and signs a statement setting out his commitment: should he fail in his promise, he can expect to pay a large fine relative to his earnings.

Dancers are highly regarded within their own cultures. Their prestige assured, they

feel free to take on any role. During Holy Week masked dancers in several regions acquire power over the community at large: they decide what fellow villagers can do, and instigate a series of taboos. Some dances offer roles to children who may be as young as three or four. They become aware at a young age of the importance of local dances, and naturally become part of that tradition.

Dances, like *fiestas*, serve to honour a patron saint or to commemorate *Carnaval*, Holy Week, the Days of the Dead and Christmas. These are not mere spectacles for tourists: they are important events that affect the life of the whole community. The financial outlay is enormous. Musicians require payment; food must be provided for villagers and for unexpected visitors. (Generally, outsiders are well received.) Although some assistance may be provided by local government, the principal costs are usually covered by the *mayordomo* (sponsor of a *fiesta*). When a man offers his services as *mayordomo*, he knows his financial liabilities will be huge. Like the dancer, however, he enjoys being part of the most important event in his community's annual cycle. He also derives enormous prestige from his actions. Meals are prepared by the *mayordomo*'s female relatives and friends; streets are adorned by the villagers themselves. Those who have no fixed role in the proceedings enjoy themselves as onlookers. It doesn't matter that the spectators have seen each dance many times already: they form an enthusiastic audience, and follow each verbal exchange with keen interest.

There is usually at least one specialist responsible for providing local people with masks. This task rarely demands more than a fraction of the maker's time. Although the majority work as farmers throughout the year, mask-makers – like dancers – can have a wide range of other occupations. Some are obliged to seek employment in a neighbouring town or city, only returning to their birth-place at weekends or during festivals. A mask-maker generally acquires his skills from his father or from a close relative, learning through observation and imitation. Women practise a great many crafts in Mexico, yet mask-makers are always male; only in exceptional circumstances does a widow continue her dead husband's calling (**10**). Production is aimed almost exclusively at dancers, who buy new masks when old ones wear out. While some makers will only work to order, others prefer to keep a small reserve of masks against last-minute requirements. Collectors, too, can buy masks directly from the makers. Although they have not been 'danced' (i.e., worn in dances), such masks could have been purchased by performers, so should be regarded as 'authentic'.

Mask-makers are respected for their great wisdom. They know the storyline of every local dance, and which facial features to give each different character. Sometimes a mask-maker will take part in a given dance, either performing or directing rehearsals. If he is responsible for a group of dancers, he may even walk at their head playing a musical instrument.

Creators of wooden masks often operate additionally as *santeros* (saint-carvers). Those who are highly skilled produce finely sculpted figures with a special finish to imitate human skin; this work is usually destined for the local church. Most *santeros*, however, carve popular saints for the domestic altars that take pride of place in indigenous homes.

Most dancers like to keep their masks in good condition: they do not relish the semblance of 'antiquity' that is so prized by collectors. Before a *fiesta*, a performer will usually take his mask back to the maker to have it repaired or repainted. (This is why old

masks often have several coats of paint.) During dances that are particularly rough, masks receive bad treatment and frequently break. Using small nails and strips of leather or tin, the maker or the dancer will later repair the worst cracks; a further coat of paint conceals these refurbishments.

There are just a few communities in Mexico where hundreds of masks are required during festivities; of necessity, their creators work full time to meet this purely local demand. Altogether different, however, is the demand driving certain wood-carvers to engage in the ceaseless manufacture of bizarre and fanciful masks that have no place in any dance. Favoured by many tourists, decorative masks of this type are now produced in enormous quantities in the state of Guerrero. Would-be collectors sometimes ask how they can recognize 'authentic' dance-masks, yet there is no wholly reliable method. Probably decorative are masks with thin and sharply projecting features, or with excessively long beards: if worn during a *fiesta*, these would easily break. There are exceptions even to this rule, however. Known dances have identifiable masks that reflect regional traditions. If a purchaser has doubts about a mask acquired from a *revendedor* (someone who re-sells), he or she has no alternative but to visit the supposed village of origin and consult the inhabitants.

In some places masks are made not by specialists but by individual dancers. Wood is rarely used in these cases, but there are exceptions. If a dancer has no mask, he may put on dark glasses. This custom is widespread: dark glasses indicate that the wearer is no longer his everyday self; he has been transformed into a different being. If a dancer wants to adopt a double disguise, he may wear dark glasses over his mask. (This last idea is wittily conveyed by the wooden mask on page 22. The maker, who lives in Zontecomatlán, Veracruz, has actually carved dark glasses on a male face.) Sometimes the identity of dancers is concealed in other ways. An oval of cardboard, with openings for eyes and a splash of paint, serves as an impromptu mask. Wrapped around the head, an embroidered or painted cloth imitates a face. A palm mat, rolled to form a point at one end, suggests a fantastic animal, while a deer's pelvis, painted and equipped with eyebrows and a moustache of *ixtle* (agave fibre), provides an ingenious and inexpensive disguise.

Sometimes masks made by dancers can achieve great complexity. Within Cora culture, each performer is honour-bound to construct his own mask for Holy Week ceremonies. He first forms a mould from raw clay, then covers it with layers of paper stuck down with flour-and-water paste. When the mask has reached the required solidity, it is left to dry. The clay is scraped away; surfaces are painted white, and edges bound with cloth. On Easter Wednesday, the mask is worn in this condition. On Easter Thursday, black lines are added. On Good Friday, the performer colours his mask using dyes most often produced from natural sources (**73**, **131**). The Mayo and the Yaqui employ the hairy skins of goats, cows, deer and other animals to fashion helmet-like masks for Holy Week (**57**, **127**). The facial area is shaved, and the skin perforated to form eye-holes. Some performers attach a nose and mouth, or even an entire face, of carved wood.

During this brief introduction to masks and mask-making, various materials and techniques have already been mentioned. Alternative materials, used in conjunction with moulds, include wax, fired clay, tanned leather, cloth and wire-mesh. An outsider might consider such fragile substances impractical, but a wax mask that perfectly fits the dancer's face while imitating the texture

of human skin is an impressive sight (**8**, **10**). Pottery masks, widespread before the Conquest, are still favoured in a number of communities (**31**). When working with leather to portray the human face, mask-makers cut away a triangular section and create a vertical seam below the chin. The leather is then soaked in water, stretched over a mould and left to dry. The resulting mask is often given painted features and sometimes a beard. During *Carnaval* in Huejotzingo, Puebla, many performers wear handsome leather masks with immense beards: these are fashioned from human hair supported on a wire frame (**7**). In other places, leather is thickly coated with gesso and painted (**59**). Some dances incorporate cloth masks: craftsmen in El Doctor, Querétaro, treat cloth strips as if they were paper, shaping them on a mould and gluing them together with paste (**55**, **56**, **88**). A quicker method is employed near Teotihuacan, however. Shown on page 30 is a mask fashioned from a felt hat: deftly re-shaped on a mould, it has been painted with bright colours. Wire-mesh is moulded in the manner of leather (**9**). Included in this book are masks made with tin, gourds, and fibreglass (see plates **100**, **1**, **96**). Yet, despite the wide range of materials now current in Mexico, wood remains the most popular.

In recent years repetitively designed masks of rubber have gained increasing acceptance. Industrially produced in factories and sold by shops throughout the land, they represent a serious threat to the individualism and artistry of Mexico's mask-makers and to the regional nature of traditional dances. Some performers are drawn to rubber masks because they are cheap and easy to come by. We can only hope that most will retain their pride in handmade masks; unique to each wearer, they also embody the beliefs and cultural values of his community.

It must never be forgotten that masks have a ceremonial function. Each year, as already described, Cora, Yaqui and Mayo masks are destroyed while each wearer undergoes ritual purification. In many villages masks are kept in the church when not in use: dancers perform in honour of the Patron Saint, and fulfil a promise made to God. Special mention should also be made of dances relating to the Days of the Dead. These are a homage to deceased ancestors who have returned to earth for a brief period to accompany the living. In some places celebrants perform the dances that are usual at other times of the year; in others, they actually represent the dead. Dances take place in streets and patios; they are performed outside the gates of cemeteries, or even inside among the graves. Such traditions underline the importance of masks in Mexico. They may be beautiful objects sought after by collectors, but first and foremost they express the identity of makers and dancers, be they Indian or Mestizo.

1 Male Display

The majority of Mexican masks show human faces with male features. These are worn on various ceremonial occasions including *Carnaval*, Holy Week, the Days of the Dead and *las fiestas patronales* (feast days devoted to the local patron saint).

The dance-cycle known as *moros y cristianos* (Moors and Christians), with its many regional variations, has given rise to a vast range of masks denoting different characters within the cycle. Throughout large areas of the Puebla highlands Christians are portrayed with red faces, because the delicate skins of the Spaniards were seen to burn with the sun. In the state of Guerrero, by contrast, red masks belong to the Moors. Although a given character may be represented with similar features in villages that are geographically and culturally close, facial expressions can vary to a remarkable degree. This is true not just of masks depicting Moors and Christians, but also of masks for another dance within the cycle, *los doce pares de Francia* (The Twelve Peers of France). While some faces appear serene, even beatific, others inspire terror in the beholder.

In pre-Hispanic times the colour black was associated with several powerful deities by the Aztec, the Tarascans, the Maya and the Mixtec. After the Conquest Spanish colonists brought Black Africans to the new continent to work as overseers on vast rural estates, as supervisors in the mines, and as stewards in wealthy houses; Black Africans also operated as muleteers, herdsmen and fishermen. Although they were slaves, their position was often an intermediary one between the Spanish settlers and the native population. Unsurprisingly, they were rapidly absorbed into indigenous dances. In 1538 the chronicler Bernal Díaz del Castillo watched a performance by one-hundred-and-fifty *negros* (Blackmen) in Mexico City. Today there are dances featuring *negros* throughout Mexico: always elegantly dressed, they have several functions. In *Faces of Fiesta: Mexican Masks in Context*, Janet Brody Esser notes that the Purépecha of Michoacán regard Blackmen as superhuman figures, or 'principal beings who control the air'. Black Africans still live along the coastlines of the Atlantic and the Pacific, but have largely disappeared from central Mexico where dances featuring Blackmen are nevertheless passed down from generation to generation. *Negro* masks vary widely, yet rarely incorporate African facial traits: painted black, they are often worn with a sheepskin to suggest hair.

The role of the ceremonial buffoon is as important today as it was before the Conquest. Many local names and styles of mask are used to designate this character. In the Nahua community of Zitlala, Guerrero, the ceremonial buffoon is termed a *huezquistle*: his red-painted, wooden mask displays a lizard on each cheek and sometimes a third on the nose (**2**). Mask-maker Juan Godinillo believes the *huezquistle* comes down to earth from the ninth heaven to join the *fiesta*. (Within Aztec cosmology, the heavens were divided into thirteen layers where the gods lived in accordance with their status.)

Many dances have agricultural links. Wearing large hats of plaited palm and tunics made from jute sacks, *los tlacololeros* simulate the planting of maize on the hillside. They crack heavy whips to suggest the noise of flames burning away old stubble. A *tigre*

1 *La mula* (Mule) from Ciudad Maíz, San Luis Potosí. This mask is worn during the dance of *los caballitos broncos* (Untamed Little Horses).
2 *Huezquistle* (Unaffiliated Old Man) from Acatlán, Guerrero. Lizards adorn nose and cheeks. This character has the role of ceremonial buffoon.

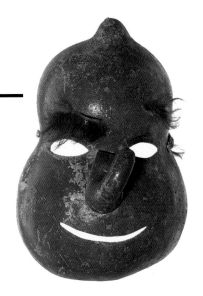

threatens the safety of the farmers, and *Juan Tirador* (Juan the Marksman) is elected to kill the beast. During the dance, *los tlacololeros* separate into pairs and fight each other with their whips; they also hunt and eventually slay the *tigre*. Masks vary from village to village, but *Juan Tirador* is usually portrayed with a simple, rather foolish expression as a defining characteristic.

Dances for *Carnaval* include a wide range of characters. In the state of Tlaxcala, during *la danza de los catrines* (Dandies), performers hold up open umbrellas to petition for rain. Using masks with pale skin-tones, and wearing top-hats and tailed dress-coats, they also poke fun at the wealthy landowners of a bygone era. Bearded masks, inspired by Ché Guevara, became immensely popular after his death. As this shows, a single dance often carries several layers of meaning. Sometimes, *Carnaval* commemorates historical events: each year the inhabitants of Huejotzingo, Puebla, re-enact a nineteenth-century battle against French invading forces. On the coast of Oaxaca, Mixtec villagers stage scenes from daily life in the main *plaza*. Carnival characters include *viejos* (Old Men), farmers, *negros*, *la muerte* (Death) and various animals; masks worn for the dance of *los tejorones* are often exceptionally small (**24, 112**). In the states of Hidalgo and Veracruz, dancers wear the same masks with different clothing for both *Carnaval* and Holy Week.

Whether male or female, masks of the human face represent the three races that together created the population of modern Mexico. Some have indigenous traits, while others depict Caucasians or Black Africans. To look at masks with these different characteristics is to recall Mexico's turbulent history at a glance.

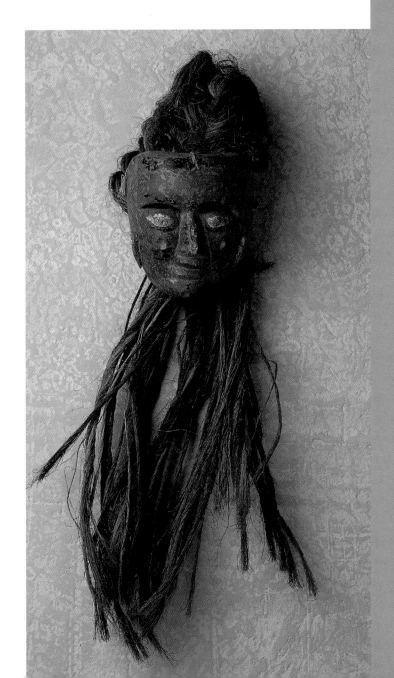

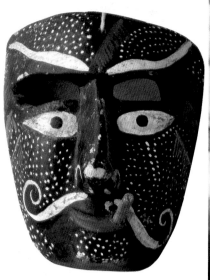

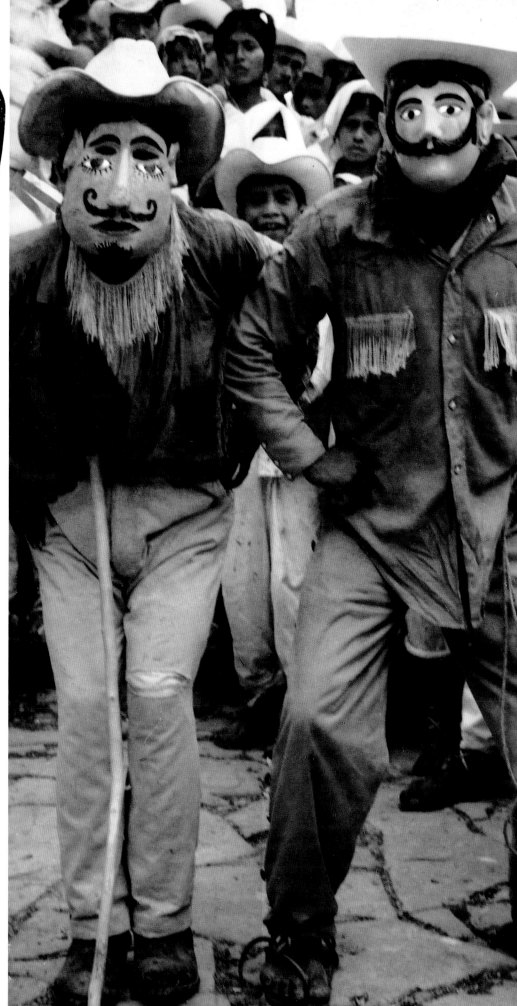

3 Black *pescador* (Fisherman) from *la danza del pescado* (Dance of the Fish) in Quechultenango, Guerrero.

4 *Huehuentones* (Old Men) act as ceremonial buffoons during the Feast of the Patron Saint in the Totonac village of Huehuetla, Puebla. Masks are of painted wood.

5 Moustachioed male characters from *Carnaval*, the *pastorela* (Christmas dance-drama) and various other dances and festivals. These masks of painted wood were made in several states including Veracruz, Tlaxcala, Guanajuato and Michoacán.

6 *Viejo de Carnaval* (Old Man of *Carnaval*) from the region of Huayacocotla, Veracruz.

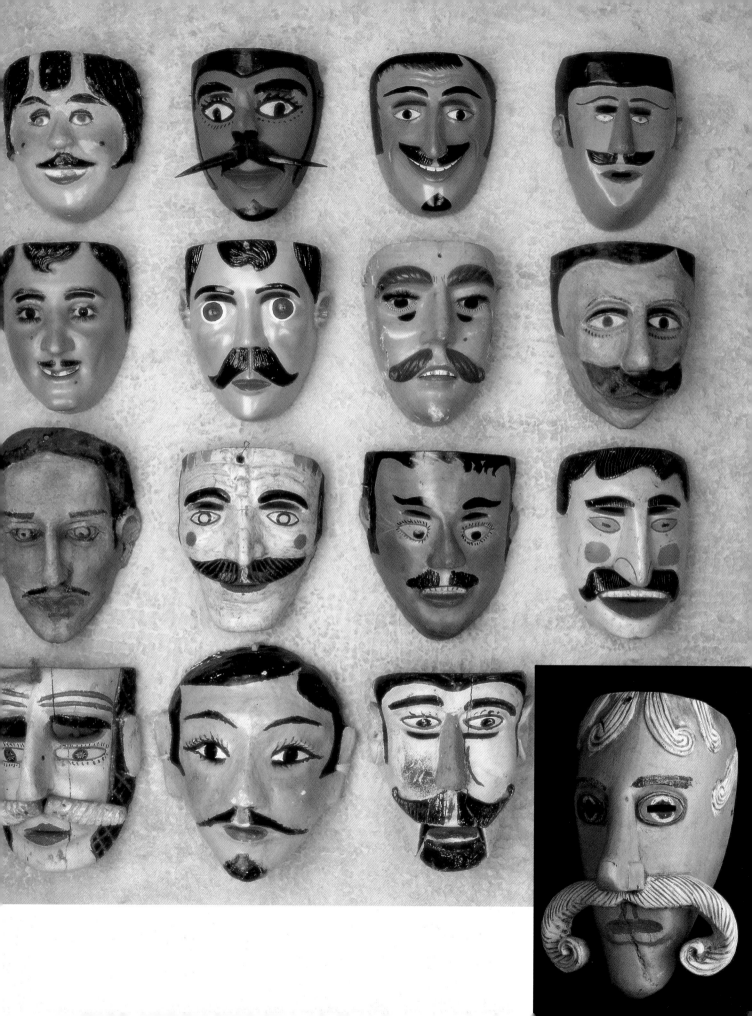

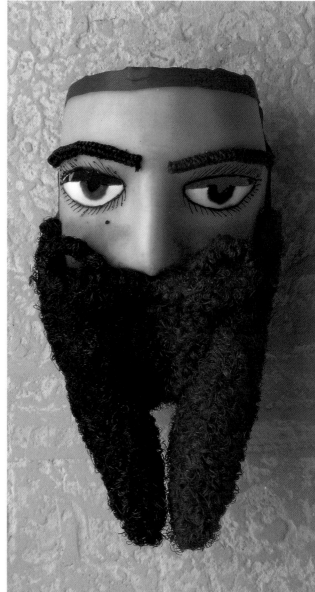

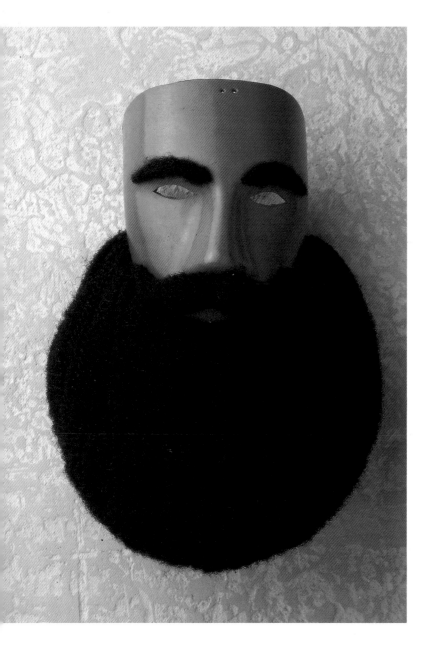

7 *Zapador* (French Captain) from Huejotzingo, Puebla. Worn during *Carnaval*, this Mestizo mask of moulded and painted leather has a seam under the chin. To construct the beard, the maker has stretched human hair over a wire frame.

8 *Viejo* (Old Man). Such masks are worn by members of the *camada de Carnaval* (*Carnaval* group) in Atenco, Chimalhuacán and other towns in Mexico State. The maker, Delfino Castillo Alonso, lives in Santa María Astahuacán in the Federal District. *Manta* (cotton cloth) has been laid over a plaster mould, starched, coloured, then encased in several layers of beeswax. Eyes, eyelashes, gold teeth and other details were painted later. Beard, moustache and eyebrows are of dyed *ixtle* (agave fibre).

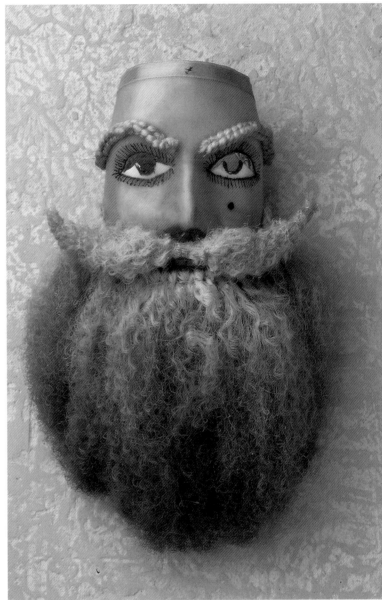

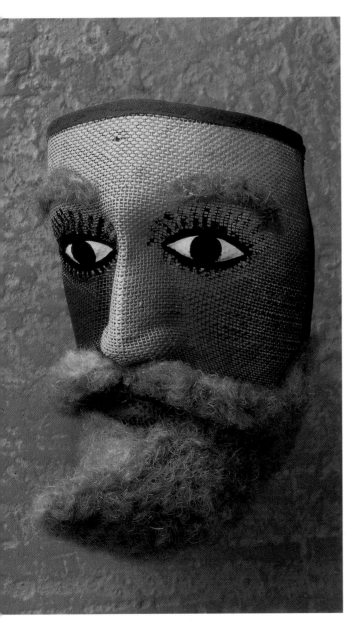

9 *Chinelo* from Tepoztlán, Morelos. This mask was made for *Carnaval* by Hector Villamil Ayala. He has used fine wire-mesh and bound the edges with cotton cloth. Beard, moustache and eyebrows are of *ixtle* fibre.

10 *Viejo*. Such masks are worn by members of the *camada de Carnaval* in Atenco, Chimalhuacán and other towns in Mexico State. The maker, Angela Torres de Castillo, lives in Santa María Astahuacán in the Federal District; she has used the technique described for **8**. The wearer attaches the mask to his head with a ribbon sewn along the top.

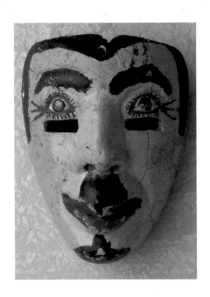

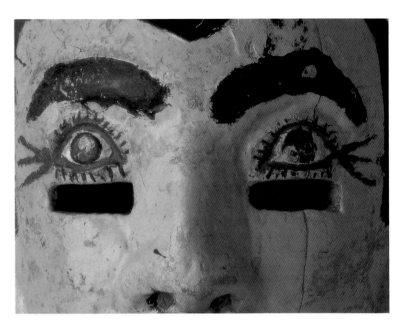

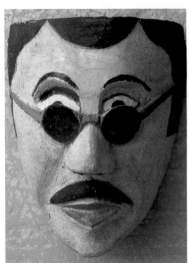

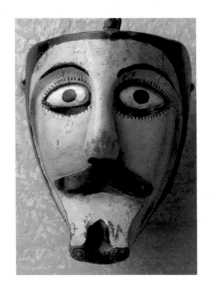

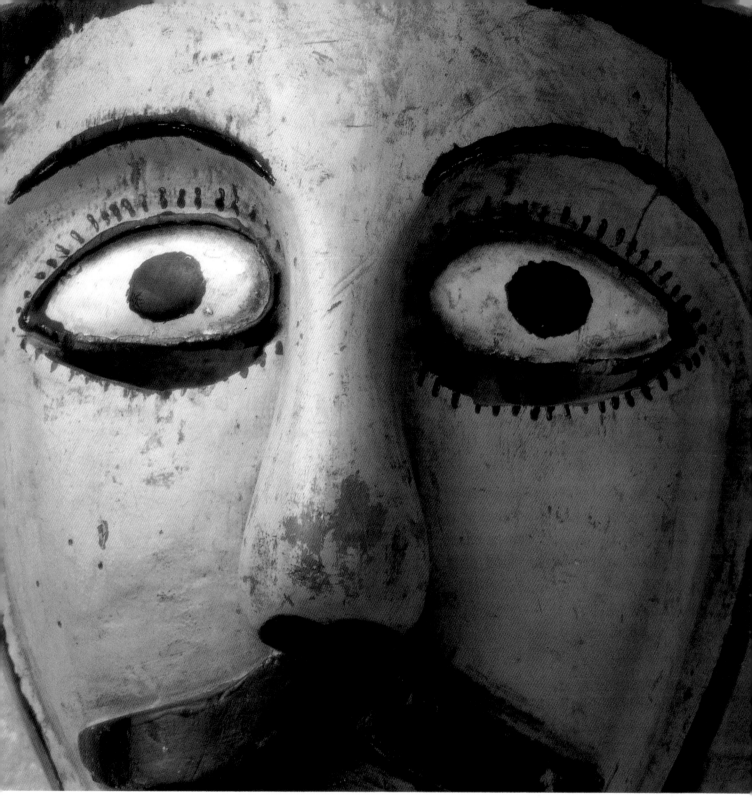

11 *Juan Tirador* (Juan the Marksman) from the dance of *los tlacololeros* (Farmers) in the Nahua community of Quechultenango, Guerrero. The mask-maker has used wood, gesso and commercial paint.

12 *Viejo de Carnaval* with dark glasses. The carver lives in the Nahua village of Zontecomatlán, Veracruz.

13 *Viejo de Carnaval* from the region of Huayacocotla, Veracruz. This wooden mask features a finely carved beard with snail shells represented at the tip.

14 *Juan Tirador.* Quechultenango, Guerrero. (detail, **11**).

15 *Viejo de Carnaval.* Zontecomatlán, Veracruz. (detail, **12**).

16 *Viejo de Carnaval.* Huayacocotla, Veracruz. (detail, **13**).

17 *Catrín* (Dandy). Roles are taken by members of the *camada de Carnaval* in Panotla and neighbouring villages. This mask was made in Tlatempan, Tlaxcala by José Reyes Juárez or by his father, Carlos Reyes Acoltzin. Features and skin tone are Caucasian; teeth are often painted gold. By pulling a string attached to a hidden spring, dancers are able to open and close the glass eyes which have eyelashes of real hair.
18 *Catrín* from Amaxac de Guerrero, Tlaxcala. Nahua dancers dress elegantly and carry umbrellas.

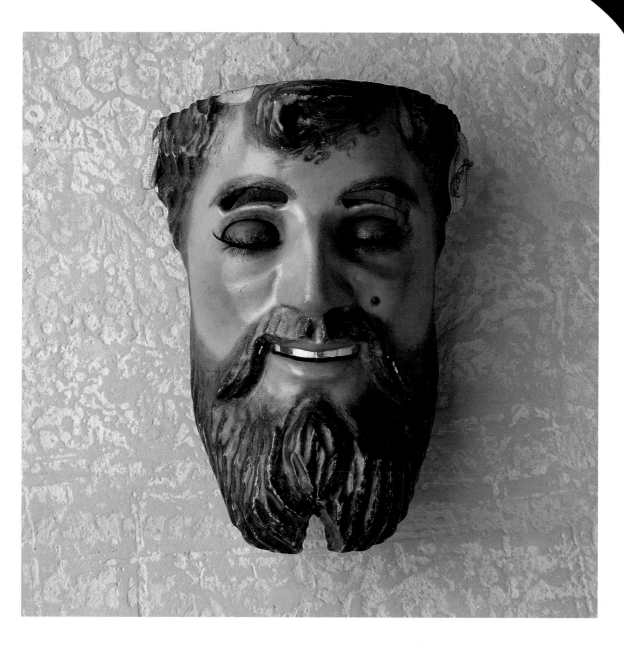

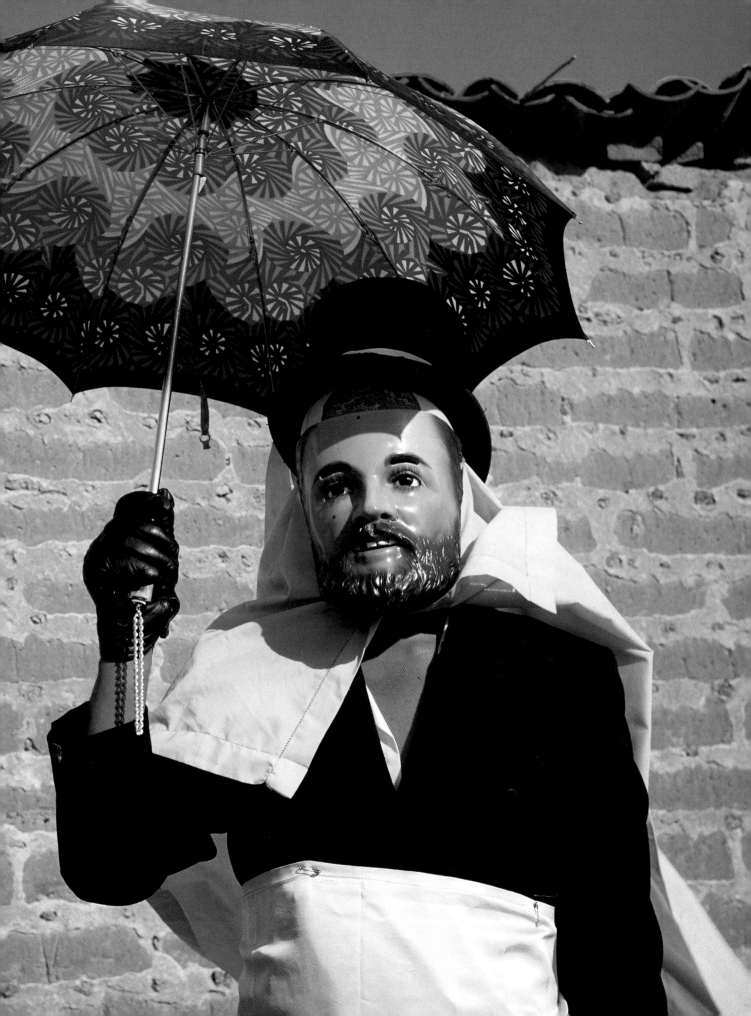

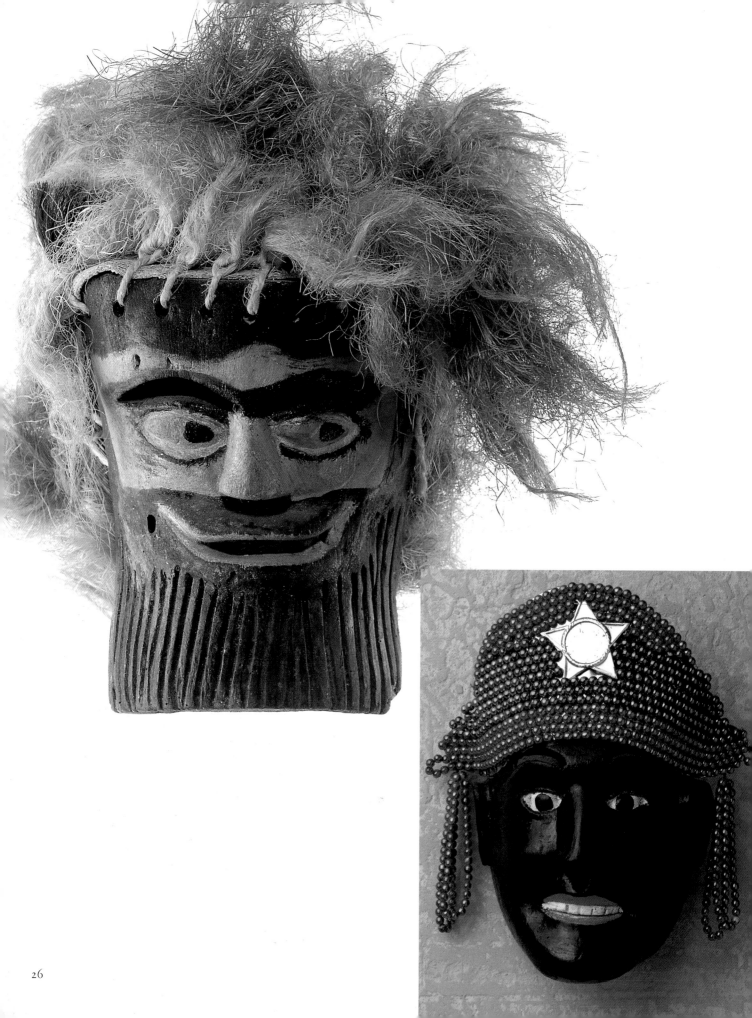

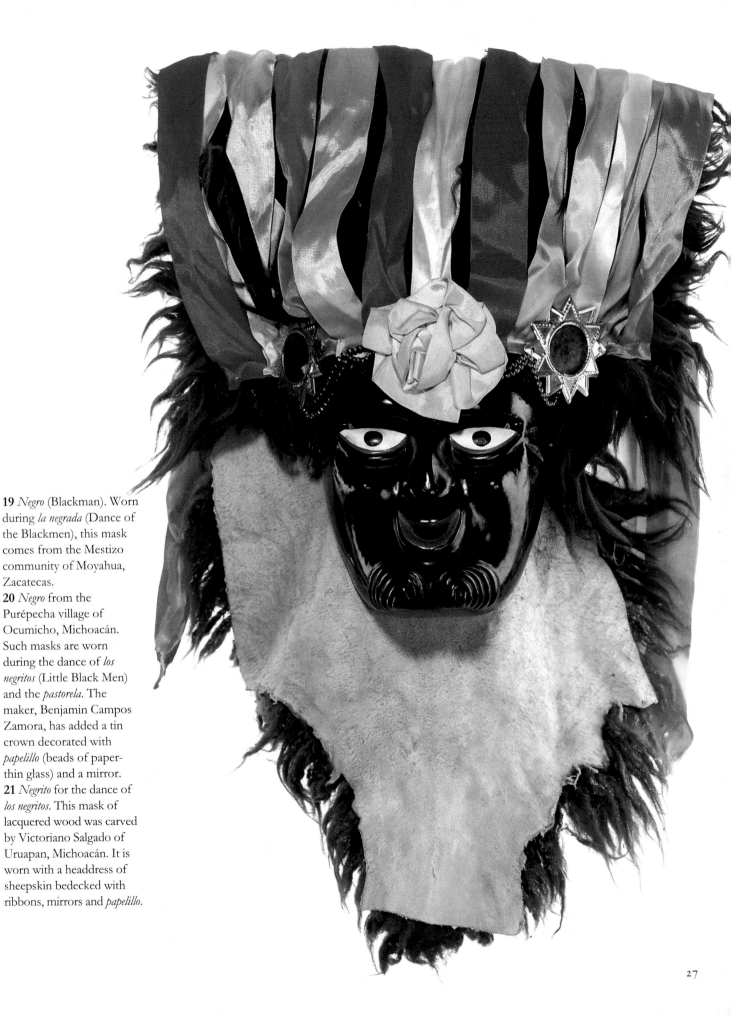

19 *Negro* (Blackman). Worn during *la negrada* (Dance of the Blackmen), this mask comes from the Mestizo community of Moyahua, Zacatecas.

20 *Negro* from the Purépecha village of Ocumicho, Michoacán. Such masks are worn during the dance of *los negritos* (Little Black Men) and the *pastorela*. The maker, Benjamin Campos Zamora, has added a tin crown decorated with *papelillo* (beads of paper-thin glass) and a mirror.

21 *Negrito* for the dance of *los negritos*. This mask of lacquered wood was carved by Victoriano Salgado of Uruapan, Michoacán. It is worn with a headdress of sheepskin bedecked with ribbons, mirrors and *papelillo*.

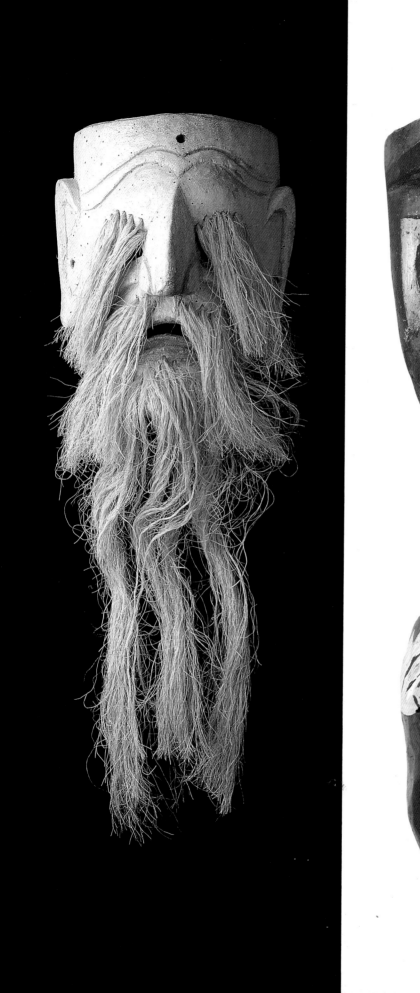

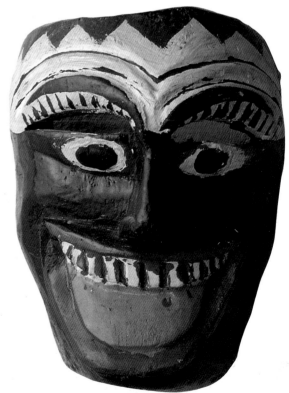

22 *Ermitaño* (Hermit) from the *pastorela* in Suchitlán, Colima. The mask-carver, Herminio Candelario, has added strands of *ixtle* fibre.

23 *Viejo* for *Carnaval* and Day of the Dead ceremonies near Huejutla de Reyes, Hidalgo.

24 *Viejo* from the dance of *los tejorones* during *Carnaval* in the coastal Mixtec community of San Juan Colorado, Oaxaca. Abnormally small masks such as these are used in conjunction with a *paliacate* (kerchief) which covers the lower half of the face.

25 *Pascola* (Old Man of the Feast) from the region of El Fuerte, Sinaloa. Made from wood, paint and cattlehair, such masks are worn by Mayo dancers during Holy Week, weddings and Day of the Dead ceremonies.

The dance-cycle known as *moros y cristianos* (Moors and Christians) has given rise to a vast range of masks.

26 *Moro* or *archareo* (also *alchareo*) from the dance of *los archareos* performed in the Mestizo town of San Martín de las Pirámides, Mexico State. The mask-maker, Juan Gómez Alcibar, has moulded and painted a felt hat; the mask is attached to sheepskin to simulate hair.

27 *Moro*, with a movable jaw and eyelashes of real hair, from *la danza de media luna* (Dance of the Crescent Moon) performed in the Mestizo town of San Felipe Tejalpa, Mexico State.

28 Male character, with a movable jaw, from the dance of *moros y cristianos* in Mexico State.

29 *Moro* from Cuetzalan, Puebla. This mask was carved by Carlos Bazán for the dance of *los santiagueros* performed in Nahua communities throughout the region.

30 *Moro* from the dance of *moros y cristianos* performed throughout the state of Guerrero.

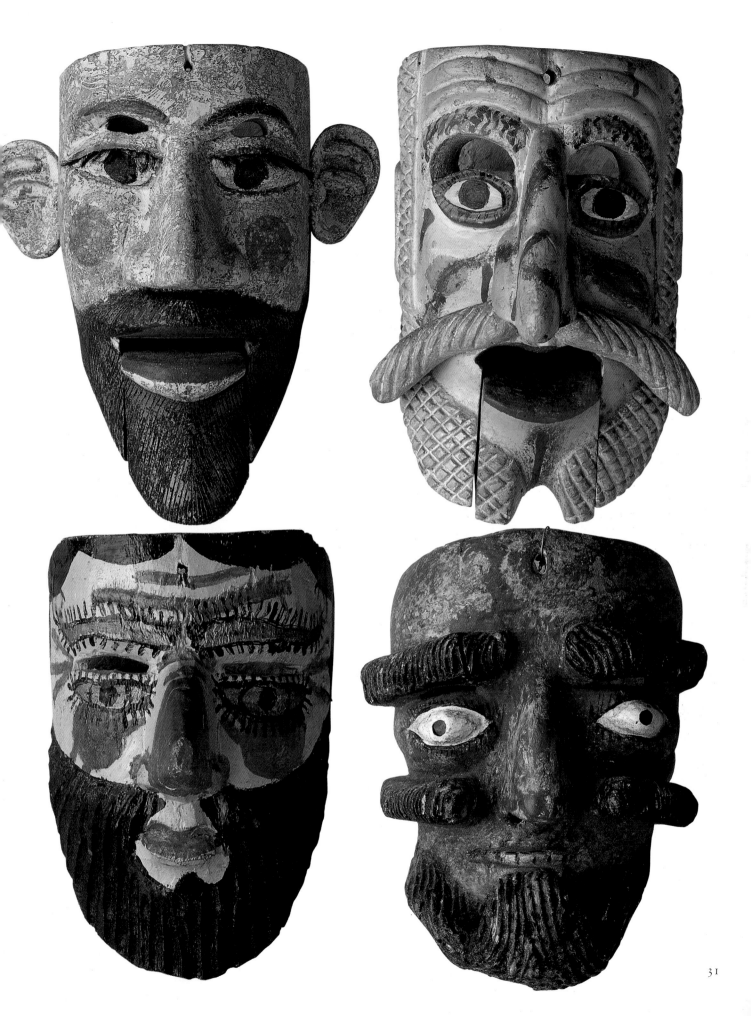

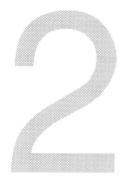

Female Faces

Before the Conquest, women took part in a number of dances and wore masks if required to by their roles. In the theatrical representations of sixteenth-century Europe, however, female roles were generally played by young men because acting was not considered a respectable calling for women. Today, during Mexican festivals, men often adopt female masks and clothing to perform as female characters. This form of transvestism is confined to the requirements of a variety of individual dances, and probably derives from the Old World antecedents that are described above.

Women in contemporary Mexico participate in relatively few dances. Some, like *los concheros*, take place in an urban setting; others, like *las varitas* (Little Rods), probably have pre-Hispanic roots. During *pastorelas* (Christmas dance-dramas) women or small girls perform as *pastoras* (shepherdesses). Henceforth, women's participation will undoubtedly intensify in many Mestizo communities. Traditions have been modified over the last thirty years, and roles once taken by men are increasingly taken by women.

In the state of Tlaxcala the shift has been far-reaching. Until the mid-1970s masked men customarily played both female and male roles during *Carnaval*. Now girls without masks partner masked male dancers. When asked about this change, one male performer in Tlaxcala replied: 'I liked things better the way they were before. Because we were all men we could indulge in a bit of bawdy joking and pretend to pinch the "girls". It was a lot of fun. Now we perform with women, so we can't behave that way. We have to show respect.'

Most 'female' roles are still played by men, however. Although women rarely intervene in dances such as *moros y cristianos*, some dances with a large cast of male protagonists do nevertheless include a female character. As the interpreter and mistress of Hernán Cortés, *la Malinche* played a crucial role in Mexican history: today she appears not just in dances relating to the Conquest, but in a number of others with different themes. Another much represented figure is *la Maringuilla* (Little Mary). Other female characters go by other names during different dances in different regions of Mexico.

The facial features of masks are appropriate to each role. A pretty mask usually describes a virtuous and modest woman who abides by the rules of her society. Less flattering masks are worn by brazen characters who behave in a grotesque manner. Included in this list of antisocial women are *las viudas* (Widows) from the *Carnaval* in Nezquipayac in the state of Mexico, and *la borracha* (Female Drunk) from *la danza del torito* (Dance of the Little Bull) in the state of Guanajuato.

Throughout the Tarascan highlands of Michoacán, groups termed *viejitos bonitos* (Handsome Little Old Men) and *viejitos feos* (Ugly Little Old Men) are accompanied by a male performer who takes the role of *la Maringuilla*. The 'Pretty' *Maringuilla* dons a mask with delicate features. She also wears regional clothing – a heavy black woollen skirt with fine pleating, a sash and an embroidered blouse. In her hands she carries a sash woven on the backstrap loom: this shows that she is an industrious woman who knows how to perform the tasks allotted to her sex. The appearance of the 'Ugly'

31 *Negra* (Blackwoman) from the dance of *los locos* ('Crazies'). Metepec, Mexico State.
32 *Vieja* (Old Woman) from the dance known as *baila viejo*. Tecoluta or Nacajuca, Tabasco.

Maringuilla is ridiculous, however. Often she parodies the behaviour of city women, whose way of life is regarded as indecent by many indigenous people. A mask or thick make-up is worn. To great comic effect, the 'Ugly' *Maringuilla* may adopt a figure-hugging dress with an exaggeratedly décolleté neckline, and pad it out to give the illusion of shapely breasts and buttocks; she may also carry a handbag as city women do. The 'Ugly' *Maringuilla* uses provocative body language; she flirts with male bystanders, makes jokes full of sexual innuendo, and shows by negative example how a respectable woman should not behave. In other regions where traditional clothing is worn, similar rules apply: although 'pretty' women generally dress as convention dictates, antisocial women do the opposite.

Female masks depict old age as well as youth. As with male masks, facial traits can suggest serenity and harmony; they can also show in caricature ugly old women or *brujas* (Witches). Although female masks are adopted by some of the performers who take the role of 'Jews' during Holy Week, their clothing is indistinguishable from that worn with male masks. 'Female' protagonists are termed *judíos* (Male Jews), and their gender seems irrelevant. Female characters abound during *Carnaval*, however, and are an integral part of most festivities. In communities where they belong to specific dances, personality and actions are determined by the storyline. In other instances, male performers simply choose a female persona as a means of disguise. Carnival masks depict lovely young girls and aged crones; they include a vast gamut of facial expressions that range widely from the serious to the comic.

33 *Maringuilla bonita* (Pretty Little Mary) from the dance of *los viejitos* (Little Old Men). The eyes are painted on glass.

34 *Maringuilla fea* (Ugly Little Mary) from the dance of *los viejitos feos* (Ugly Little Old Men). Both masks were carved from local wood by Antonio Saldaña in the Purépecha village of San Juan Nuevo, Michoacán.

35 *Soldadera francesa* (French Soldier-Woman) for *Carnaval* from Huejotzingo, Puebla. The mask-maker, Carlos Saloma Lozano, has used moulded leather and commercial paint; the seam runs under the chin.

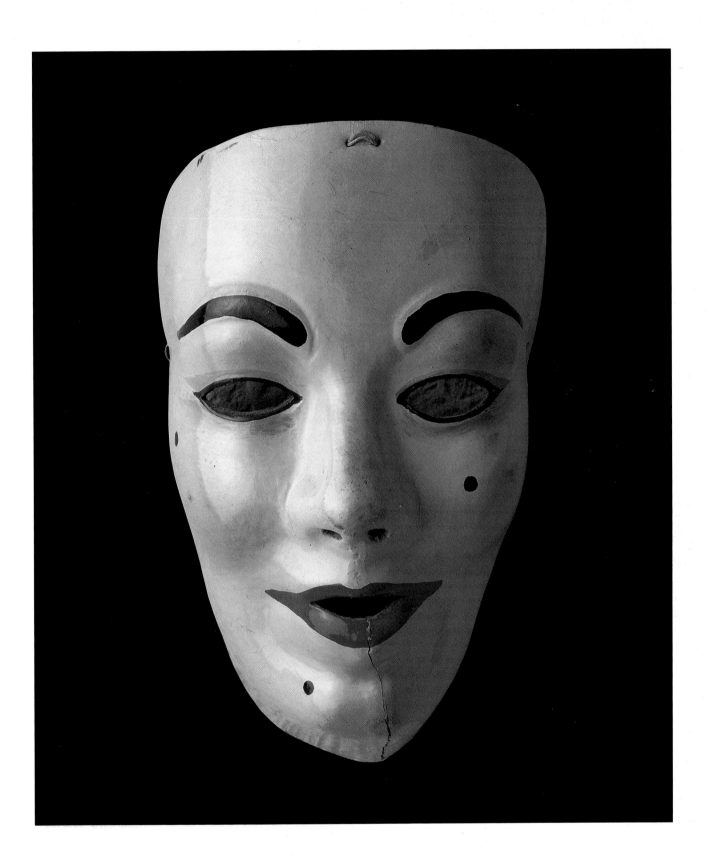

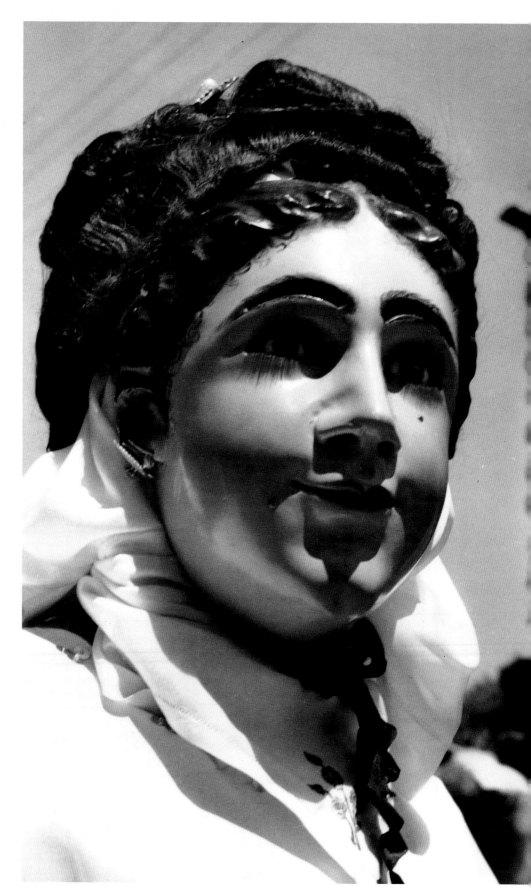

36 Female character played by a Nahua man during *Carnaval* in Tepeyanco, Tlaxcala. 'She' wears elegant, white clothing and a wig; the wooden mask is finely carved and painted. By pulling a string attached to a hidden spring, the dancer is able to open and close the glass eyes which have eyelashes of real hair.

37 *Maringuilla* from *los paragüeros*. This dance is performed during *Carnaval* in Papalotla and other Nahua communities in the state of Tlaxcala. The maker, Enrique Méndez Juárez, lives in Puebla City.

38 *Maringuilla bonita* from the dance of *los viejitos*. This mask was carved by Manuel Valencia Chávez of Sevina, Michoacán.

39 *Maringuilla bonita* from the dance of *los viejitos*. The maker, Benjamin Campos Zamora, lives in the Purépecha village of Ocumicho, Michoacán.

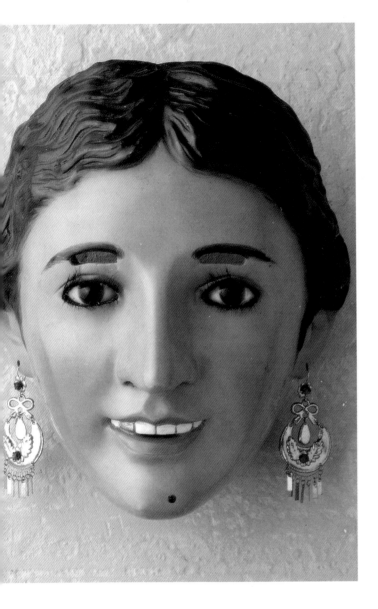

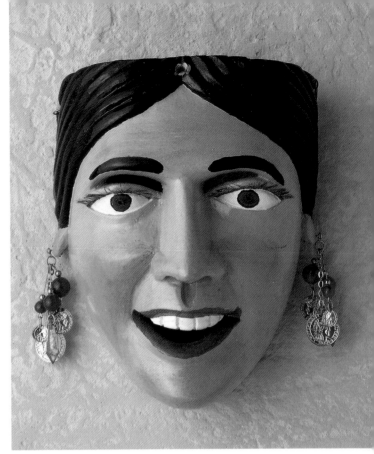

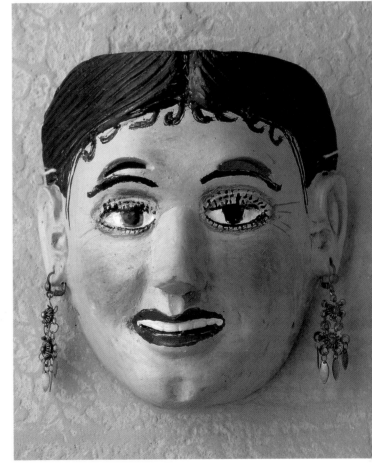

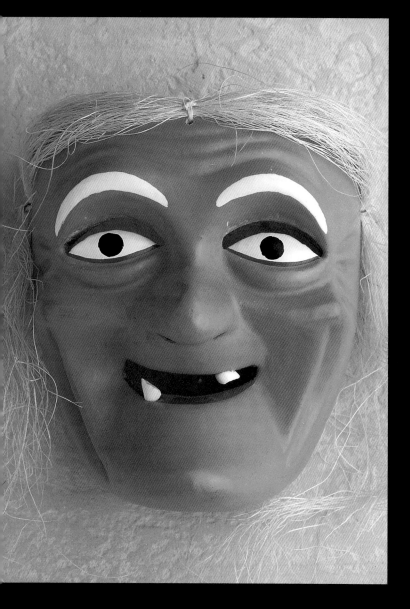

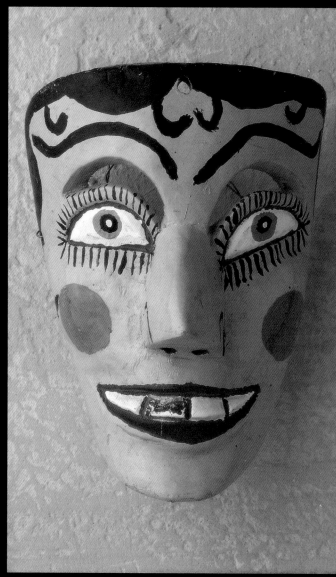

40 *Viejita* (Little Old Woman) from the dance of *los viejitos*. This mask was carved by Victoriano Salgado of Uruapan, Michoacán.

41 *Vieja* (Old Woman) from the dance of *los huehues* (Old Ones). This mask was made in Apango, Guerrero.

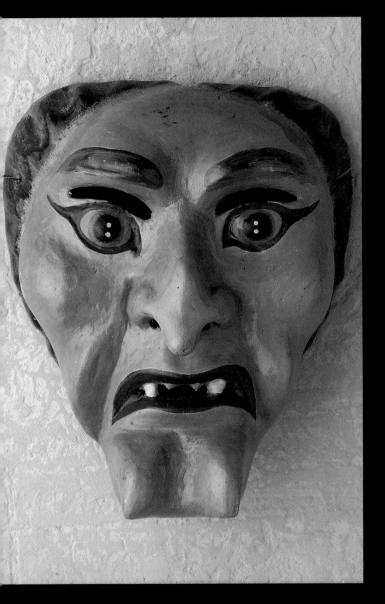

42 *Vieja* from the dance of *la tortuga* (Turtle), performed during the dance of *los tejorones*. This mask was carved by José Luna of Huazolotitlán, Oaxaca.

43 *Vieja* from the dance of *los manueles*. The mask-carver, the late Nolberto Abrajám, used to live in Tixtla, Guerrero.

44 Comic female character for *Carnaval* from San Cristóbal de las Casas, Chiapas. The mask-maker has used moulded strips of agglutinated paper and commercial gloss paint. Dancers open the eye sockets in their masks before using them; this example, however, has not been worn.

45 *Bruja* (Witch) from the dance of *los tecuanes*. This large mask of lightweight wood was carved by Efraín Jiménez Ariza of Acatlán, Puebla. Strands of *ixtle* fibre are glued to the top of the head and secured with strips of cloth.

46 (*inset*) *Bruja* from an unknown dance performed in the Sierra de Juárez, Oaxaca. The blood of her victims is represented by red paint around the mouth.

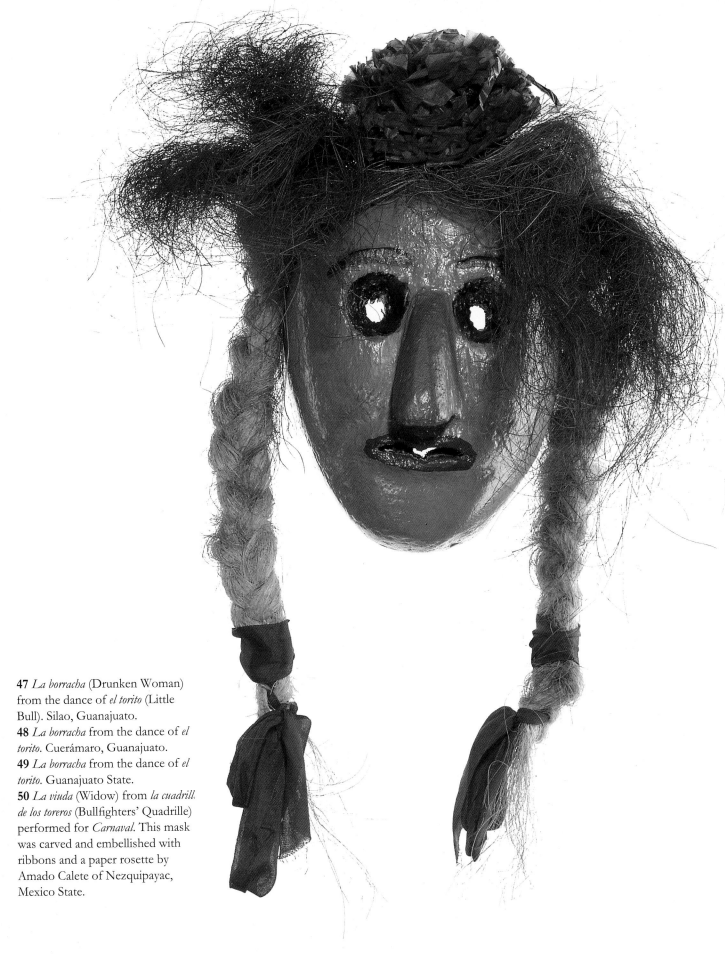

47 *La borracha* (Drunken Woman) from the dance of *el torito* (Little Bull). Silao, Guanajuato.
48 *La borracha* from the dance of *el torito*. Cuerámaro, Guanajuato.
49 *La borracha* from the dance of *el torito*. Guanajuato State.
50 *La viuda* (Widow) from *la cuadrilla de los toreros* (Bullfighters' Quadrille) performed for *Carnaval*. This mask was carved and embellished with ribbons and a paper rosette by Amado Calete of Nezquipayac, Mexico State.

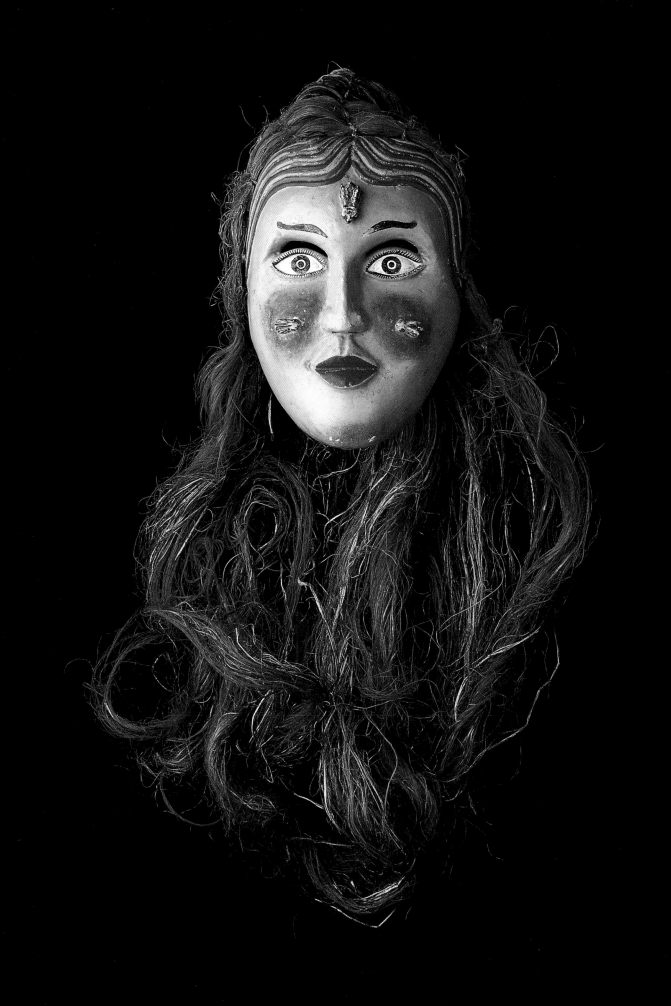

La Malinche, interpreter and mistress of Hernán Cortés, appears in a large number of dances.

51 Representation in painted wood with hair of dyed *ixtle* fibre from Guerrero State. The mask-maker has portrayed this character with insects on forehead and cheeks.
52 Representation in painted wood with earrings and horsehair tresses from Acapetlahuaya, Guerrero. Here, *la Malinche* is shown with markedly indigenous features.
53 Representation in painted wood with metal teeth from Acatlán, Puebla. The paint has partially rubbed off.

Female masks are sometimes worn by male peformers who take the role of 'Jews' during Holy Week ceremonies.

54 *Judío* (Jew) from the Pima community of Tonichi, Sonora. This mask was achieved with agglutinated paper and commercial gloss paint. The cardboard hat is covered with crêpe-paper decorations.

55, 56 *Judíos* (Jews) shown in the guise of an old woman (**55**/top) and a young woman (**56**/below). These masks were made with agglutinated, moulded cloth by Guadalupe Olvera of El Doctor, Querétaro; they attach round the wearer's head with ties of cotton cloth.

57 *Chapakoba* (Pharisee, Jew) for Holy Week in the Mayo community of El Fuerte, Sinaloa. This helmet of partially shaved and painted deerskin also incorporates wood, wire-mesh, paper flowers and streamers.

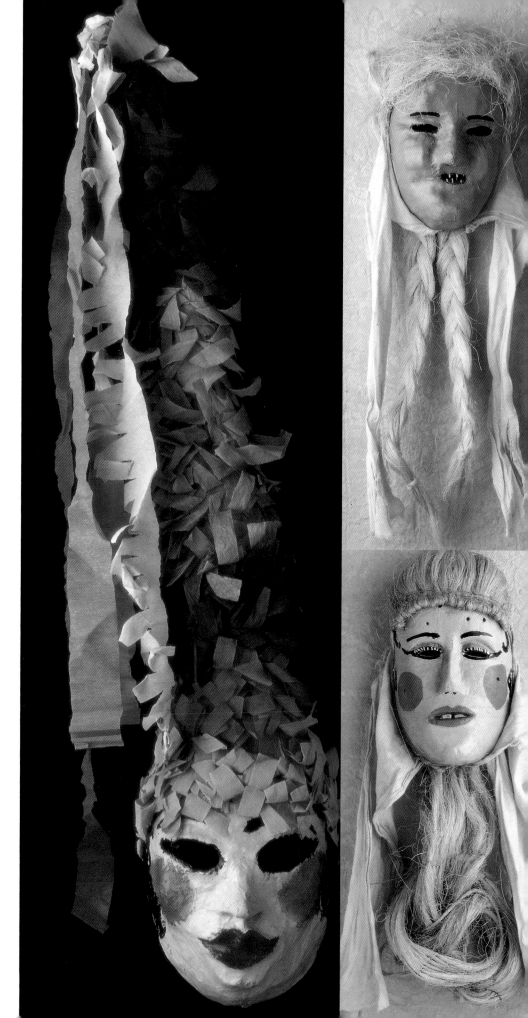

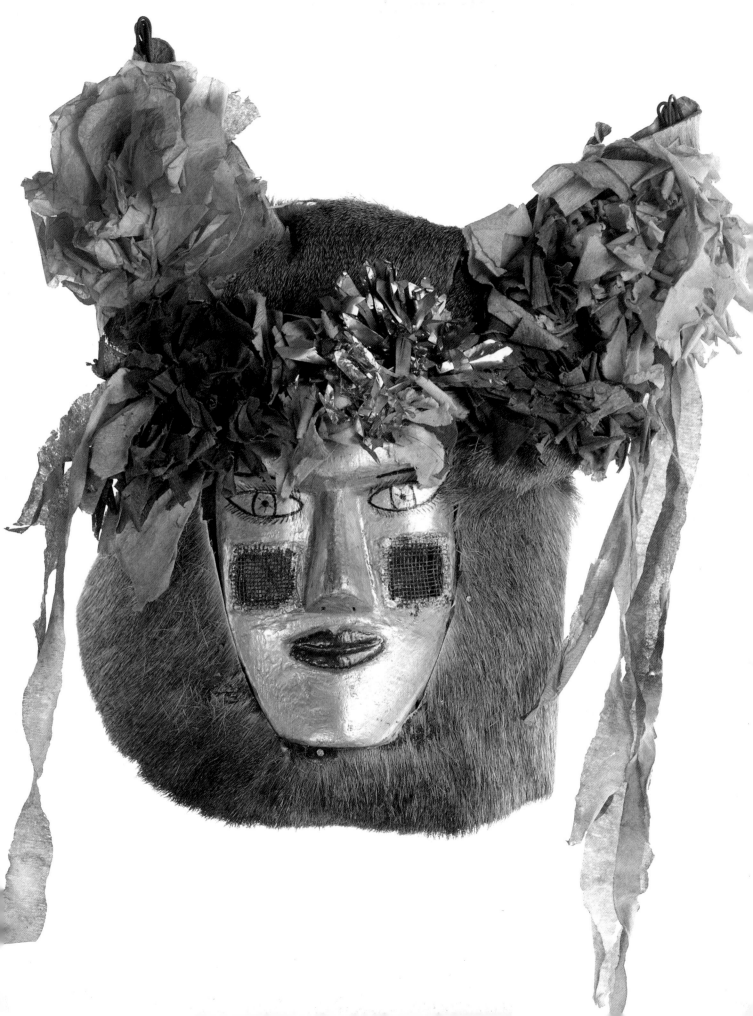

3 Dominion of the Animals

In Mexico, according to popular belief, each man and woman shares a common destiny with an animal counterpart. If someone is without food, the animal will go hungry; if the animal suffers injury, the human being will become ill; if the animal is killed, the human being will die. *Tona* (also *tono*) is the term for this animal guardian or soul companion.

Before the Conquest each deity also had a *tona*. Tezcatlipoca, the 'Smoking Mirror', was a very important god in Aztec cosmogony. Nocturnal and invisible, he was represented by an obsidian mirror. He could bestow riches and good fortune or withhold them at whim. His *tona* was the jaguar, popularly known throughout modern Mexico as the *tigre* (tiger). This may be why the *tigre* is the most revered and feared of animals.

Throughout the state of Guerrero, Náhuatl (the Aztec language) is widely spoken. In dances such as *los tlacololeros* (Farmers), *los tecuanes* (Wild Beasts) and *los tejorones*, the *tigre* is a malevolent beast and must be killed by hunters who approach him in terror. Other dances, by contrast, portray him as the bringer of the harvest. In Atzacoaloya, Guerrero, the *tigre* goes from house to house collecting the first maizecobs of the year: only after he has taken these to be blessed in the church, can the ripe maize be eaten. In Olinalá, Guerrero, *tigres* form a procession, each carrying great bundles of chilli peppers and other agricultural produce. The *tigres* of Zitlala, Guerrero, are far fiercer, however. Roles are taken by young men from two rival *barrios* (districts). As they engage in fierce fighting, performers may be reliving a distant memory of Aztec valour by emulating the great warrior order of the 'Jaguar Knights'. In the words of one dancer, 'Our

battles are a kind of sacrifice. We fight to be sure of good rain in the future.'

Although some *tigre* masks are small or average in size, others are far larger than the human face; in these cases dancers look out through the open jaws. *Tigre* masks in Zitlala resemble helmets: made from two or three thick layers of leather, they protect the wearer from the blows of adversaries. They can only be put on when wet, because dry helmets are too tight to admit an adult head. Many masks feature eyes of round mirrors, recalling Tezcatlipoca's obsidian mirror.

Spanish chroniclers of the Conquest period mentioned a wide range of animal disguises; today these are no less varied. Creatures indigenous to the New World include monkeys, *tejones*, armadillos, rabbits, hares, boars, owls, vultures, fish, alligators, lizards, serpents and many others. The monkey has traditionally been associated with song and dance; today monkey characters appear most often during *Carnaval*. The owl is widely thought to bring bad luck: according to one popular saying: 'When the owl hoots, the Indian dies.' Alligators, as portrayed by some wood-carvers, often bear a close resemblance to the *cipactli*. This acquatic creature of pre-Hispanic legend was reputed to have a row of dorsal spikes.

An important figure since ancient times, the serpent still symbolizes rain in modern Mexico. Although farmers desire rain for their crops, they also fear the floods that too much rain can bring. Today snakes are frequently portrayed on devil masks (**120, 121**). In some regions dancers extend the notion of face-masks by wearing the carved wooden head of a serpent on their backs. Shown on page 52 is a 'dorsal mask' of a

58 Monkey for *Carnaval*. The mask-carver, Adulfo Castillo Aguilar, lives in Alto Lucero, Veracruz.
59 *La perra maravilla* (Wonder Bitch), with a lizard on her nose, from the dance of *los tastoanes* (Moors). Santa Cruz de las Huertas, Jalisco.

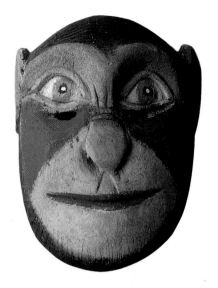

similar type but representing a pig: the fresh maizecob links the mask with fertility.

In bygone times, when people derived much of their food from hunting, the human relationship with the animal world was an intimate one. During *la danza del venado* (Deer Dance), current among the Yaqui and the Mayo of northern Mexico, performers simulate a hunt which ends with the death of the deer. Felipe Molina, a Yaqui anthropologist, recalls the teachings of his grandfather. When people had to kill a deer, they would first organize a *fiesta* to ask the deer's forgiveness. They would tell the deer that they needed to eat his body and clothe themselves in his skin. While one future hunter became 'little brother deer', the rest acted as his pursuers and captors. To disguise himself during this ancient ritual, the man-deer wore the dried head of a real deer on his own head. This tradition survives unchanged.

Old World animals also feature in numerous dances. Goats, bulls and dogs are widely represented. When performing *los viejos* (Old Men) in Cuilapan, Oaxaca, some dancers invariably wear goat masks. As *los viejos* cavort through the streets, they write the date of the year that is ending on the walls of houses. Their dance is performed during the months of July and August, yet they represent the dying year. The role played by the dog is the same as in real life: as man's friend, the dog accompanies him on hunting expeditions. In this context the dog is called *la perra maravilla* (Wonder Bitch).

Although some dances are devoted to a single species, the storyline of others involves a host of different creatures. During *Carnaval*, Holy Week and other festivals, animal characters often mix with men and women, devils and Death.

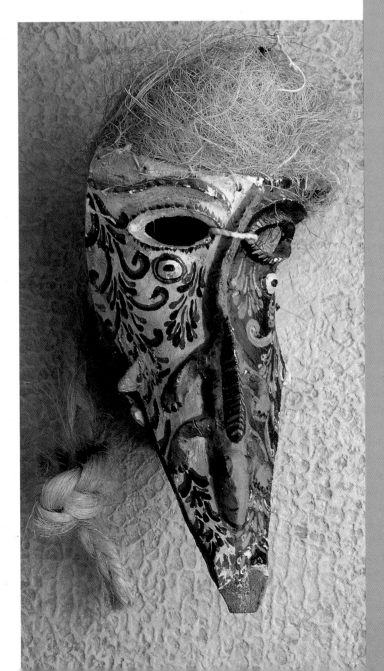

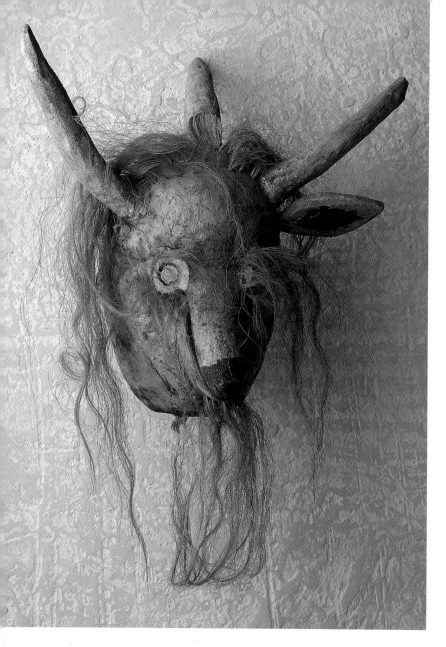

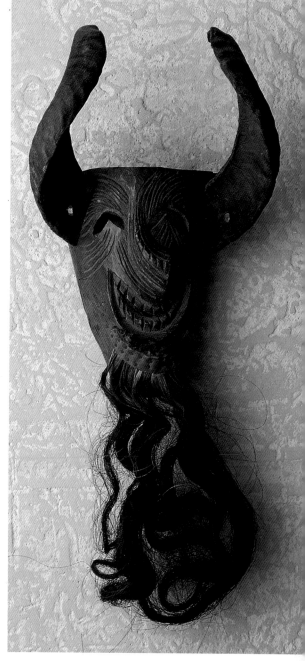

Since their introduction into the New World by Spanish colonists, goats have been much represented by Mexican mask-makers.

60 *Viejo* (Old Man), in the guise of a goat, from the dance of *los viejos*. Made from painted wood and cowhair, this mask comes from the Mixtec village of Cuilapan, Oaxaca.
61 *Macho cabrío* (Billy Goat) for *Carnaval* from the Otomí community of El Nante, Hidalgo. The mask-maker has used unpainted wood with real goat horns and hair.
62 Goat, with real goat horns, for the dance of *los tejorones* from the coastal Mixtec community of Pinotepa de Don Luis, Oaxaca.

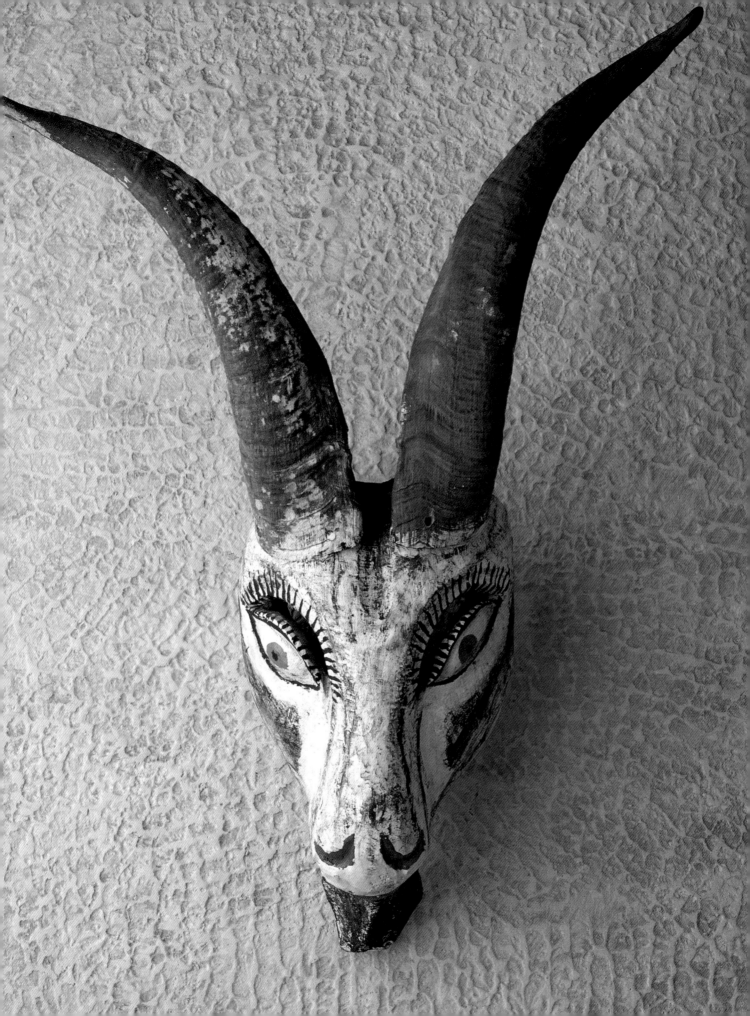

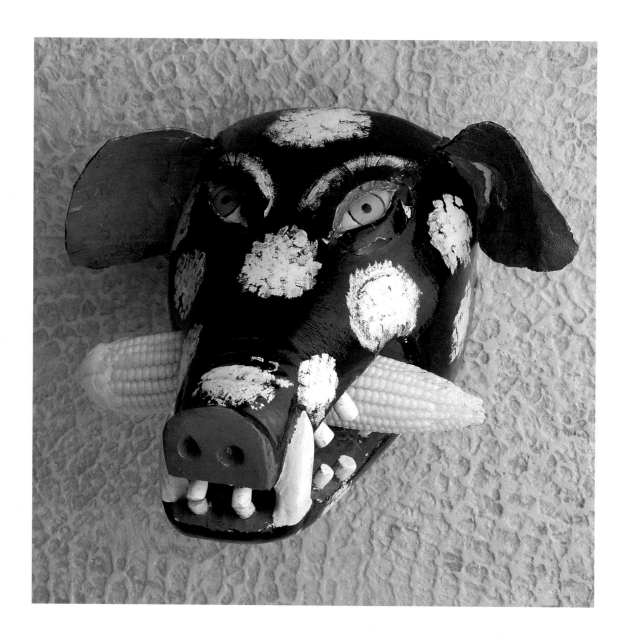

63 Pig from the Zoque community of Ocozocuautla, Chiapas. A fresh maizecob has been inserted between the jaws. The performer wears this head on his back during *Carnaval* for the dance known as *Mahoma de Cochi*.
64 Boarlike creature from an unknown dance performed by the Chatino inhabitants of Yaitepec, Oaxaca.

65 Dog for the dance of *los tlacololeros* or *los tecuanes* from the state of Guerrero.
66 Dog from the dance of *los tecuanes*. This mask was carved by Efraín Jiménez Ariza of Acatlán, Puebla.

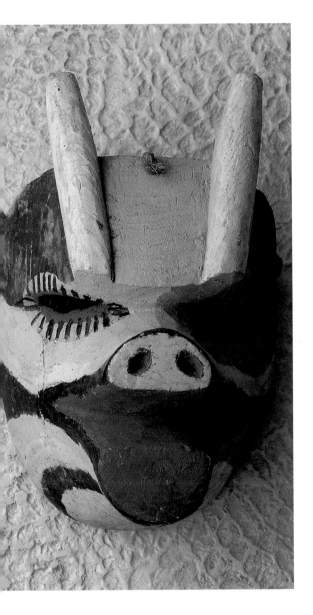

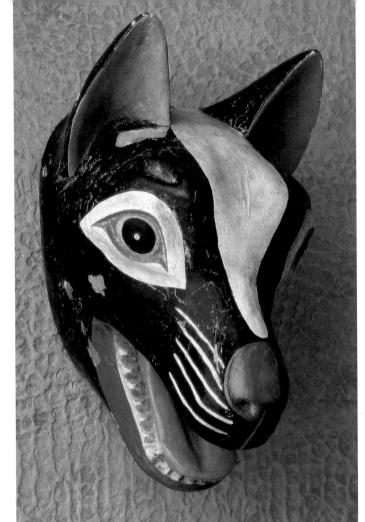

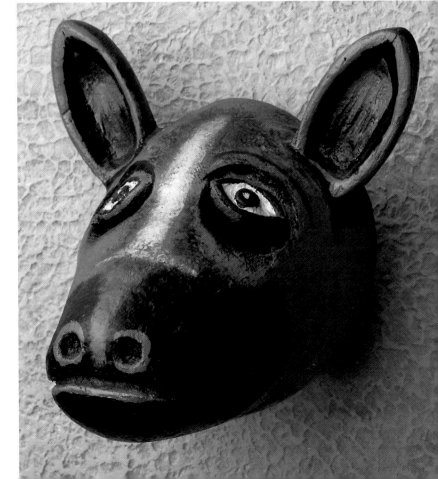

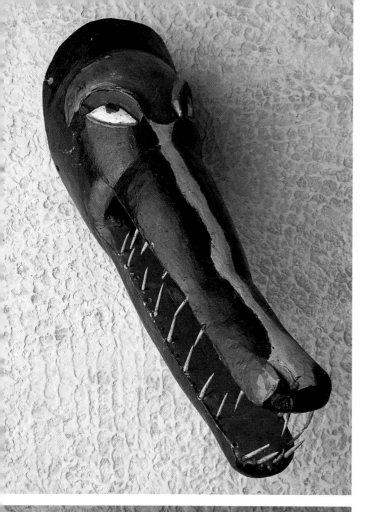

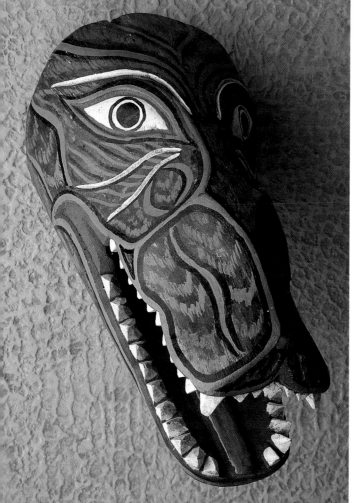

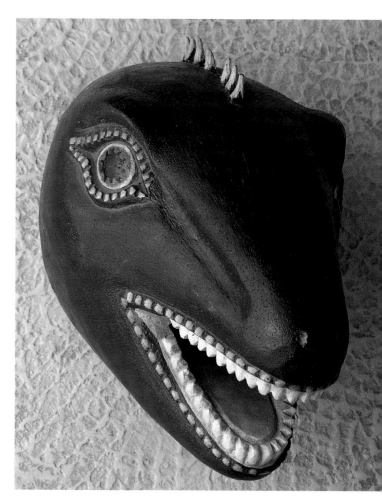

Alligators and lizards are indigenous to Mexico.

67 Alligator from the dance of *los tejorones*. The mask-carver, who lives in the coastal Mixtec village of San Juan Colorado, Oaxaca, has used thorns for teeth.
68 Lizardlike creature from the dance of *los tejorones*. This mask was carved by José Luna in the coastal Mixtec village of Huazolotitlán, Oaxaca.
69 Alligator from the dance of *los tejorones* performed in the coastal Mixtec region of Oaxaca.

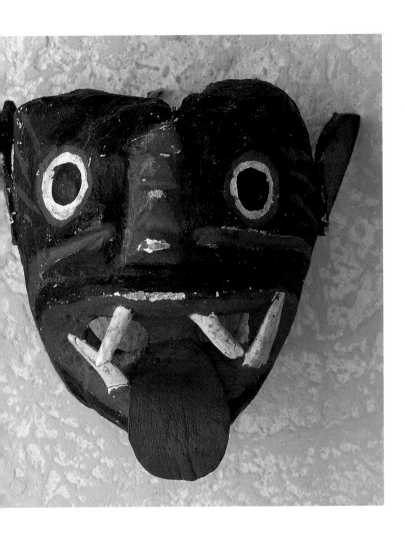

70 Fish from the dance of *los pescadores* (Fishermen). The mask-carver, who lives in the Nahua village of Tlacotepec, Guerrero, has incorporated animal teeth. The ears and tongue are of leather.

71 Fish. In the region of Huejutla de Reyes, Hidalgo, such masks are worn by Nahua performers during *Carnaval* and Day of the Dead ceremonies.

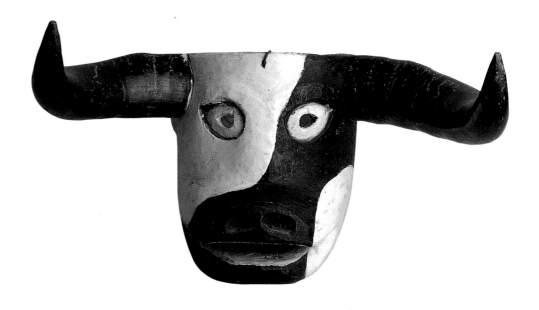

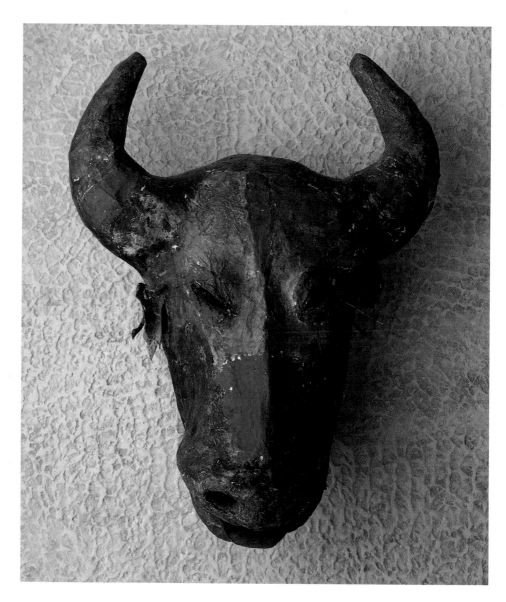

Bulls were introduced into Mexico from Spain.

72 Bull for *Carnaval* from Xico, Veracruz. The mask-carver, David Reynaldo Tepo, has incorporated a bull's horns.

73 Bull for Holy Week ceremonies in the Cora community of Jesús María, Nayarit. The maker has used moulded paper and glue, aniline dyes and a black colourant derived from the ashes of burnt maizecobs. The edge of the mask is bound with cloth.

74 Bull for *Carnaval* from Alto Lucero, Veracruz. The mask-carver, Adulfo Castillo Aguilar, has added leather ears and a mirror; the cloth-covered palm hat displays rectangular mirrors and paper flowers with glitter.

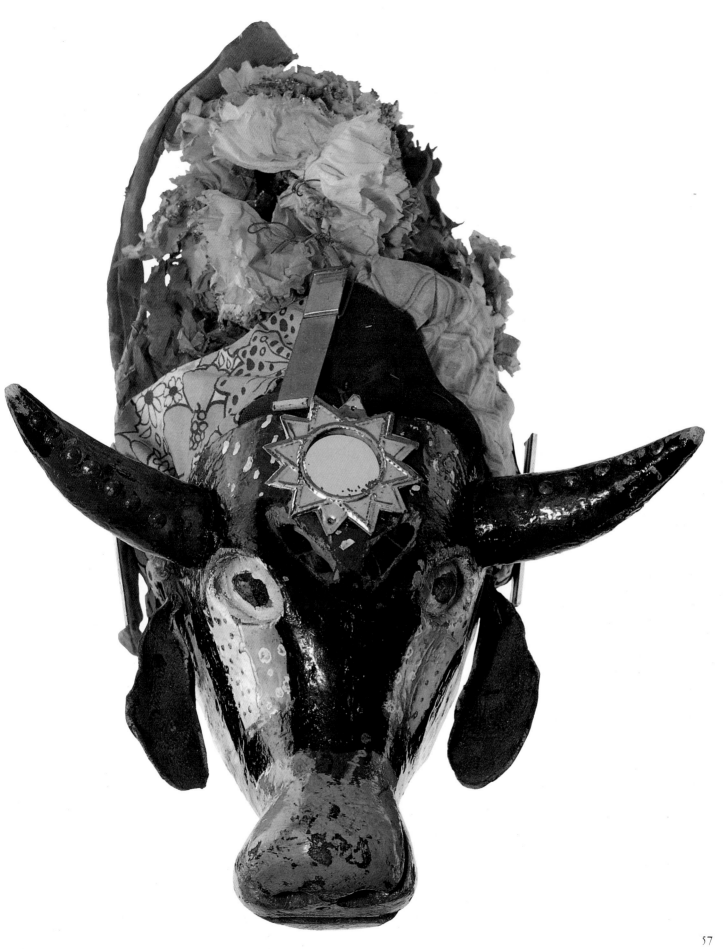

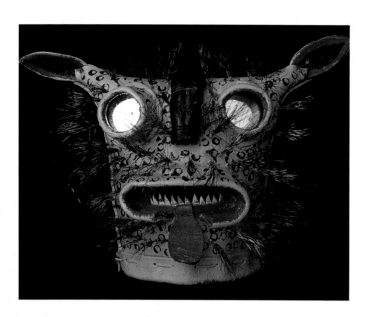

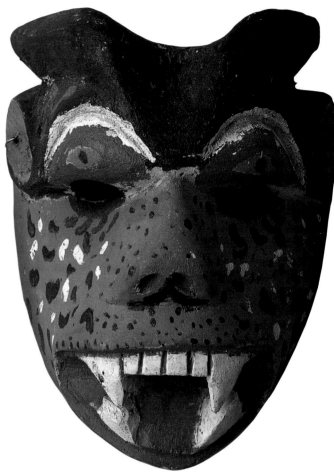

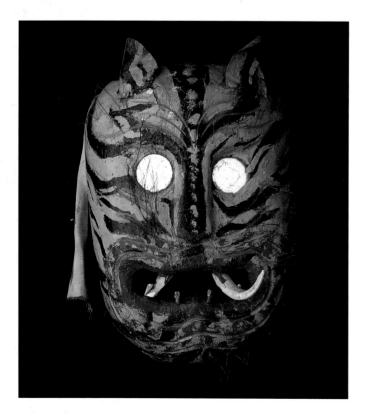

75 *Tigre* from *la batalla de los tigres* (Battle of the 'Tigers') in the Nahua village of Zitlala, Guerrero. The maker, Melesio Salazar Tepetute, has superimposed two layers of leather to form a helmet, then added boar's whiskers and mirrors for eyes. In recent years, the mask has been repaired and repainted.

76 *Tigre* from the dance of *los tejorones* in the Chatino community of Yaitepec, Oaxaca.

77 *Tigre* for harvest celebrations in the Nahua village of Atzacoaloya, Guerrero. The mask-carver has incorporated leather ears, mirror eyes, animal teeth and boar's whiskers. A painted cloth flap covers the back of the wearer's head.

78 *Tigre* during *Carnaval* in the Mixtec village of Juxtlahuaca, Oaxaca. The dancer's clothing is spotted with paint to simulate animal markings; his painted wooden mask is equipped with a leather tongue.

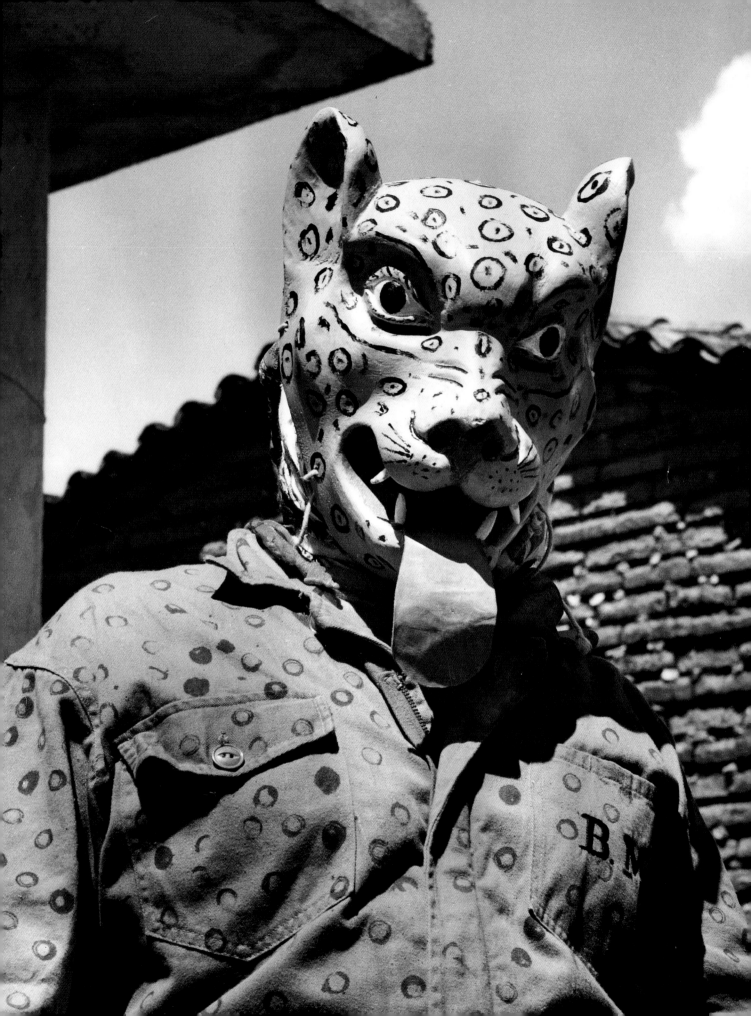

79 *Tigre* for Corpus Christi celebrations in the Mestizo town of Suchiapa, Chiapas. Carved by Oliver Velázquez Serrano, this mask is worn in the manner of a helmet: the dancer looks through the gap between wood and cloth.

80 *Tigre* from the dance of *los tejorones* in the coastal Mixtec village of San Juan Colorado, Oaxaca. The mask-carver has added mirrors for eyes and whiskers of horsehair.

81 *Tigre* from the dance of *los tecuanes* (Wild Beasts) performed in the Mestizo town of Acatlán, Puebla. This unusually large mask was carved from lightweight wood by Norberto Simón of Ahuehuetitla, Puebla.

82 *Tigre* from the dance of *los tejorones* in the coastal Mixtec town of Pinotepa Nacional, Oaxaca. The mask-maker, Filiberto López Ortiz, has used wood, gesso and a special paint mixture.

83 *Tigre* from Olinalá, Guerrero. Nahua performers take part in a procession of *tigres*. The mask-carver has added a leather tongue, animal teeth, clear plastic over the eyes and a boar's whiskers. The wood is covered with two coats of lacquer in contrasting colours. With this technique, known as *rayado*, the top coat is partially scraped away. Black, raised motifs include birds and animals.

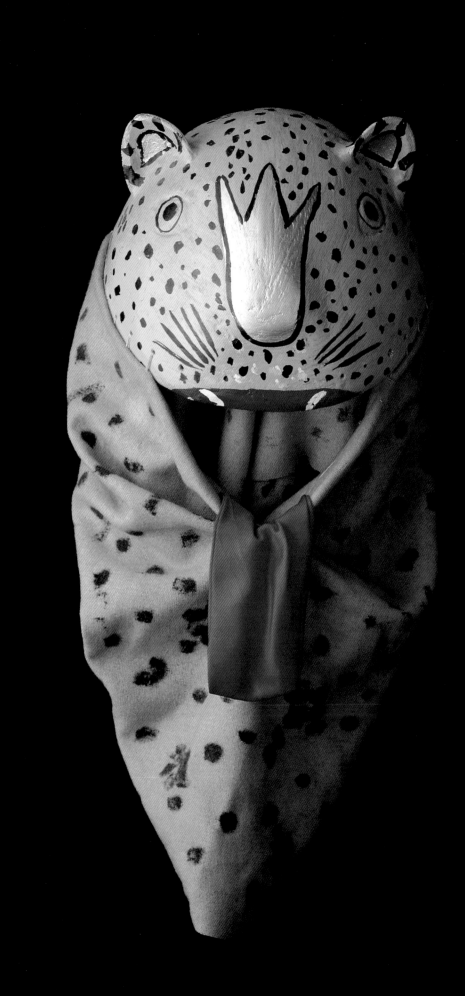

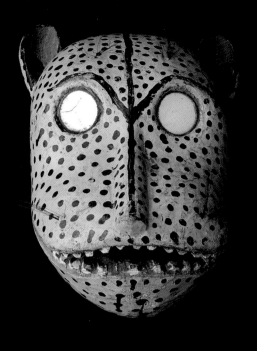

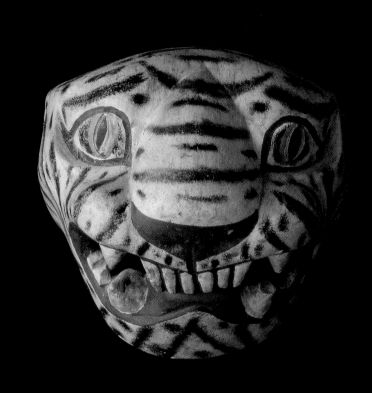

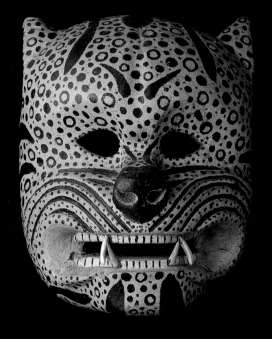

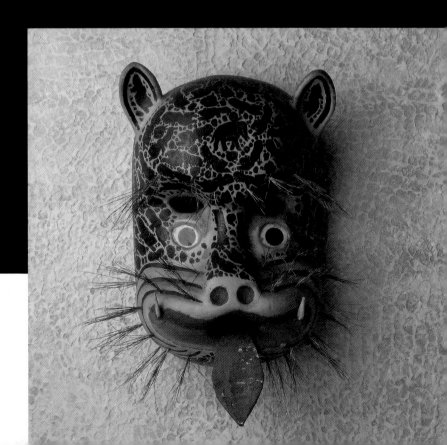

84 Owl from the *pascola* dance. This mask of painted wood and goathair was made in the Guarijío community of San Bernardo, Sonora.

85 Owl from an unknown dance in the state of Guerrero.

86 Owl from the Nahua community of Suchitlán, Colima. Carved in one piece by Herminio Candelario, this mask belongs to the dance known both as *la danza de los animales* (Animals) and *la danza de los morenos* (Dark-skinned People).

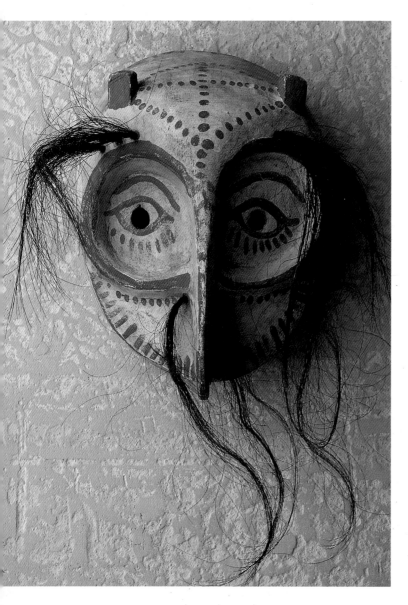

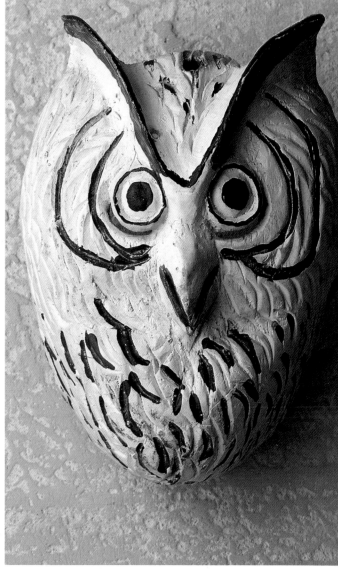

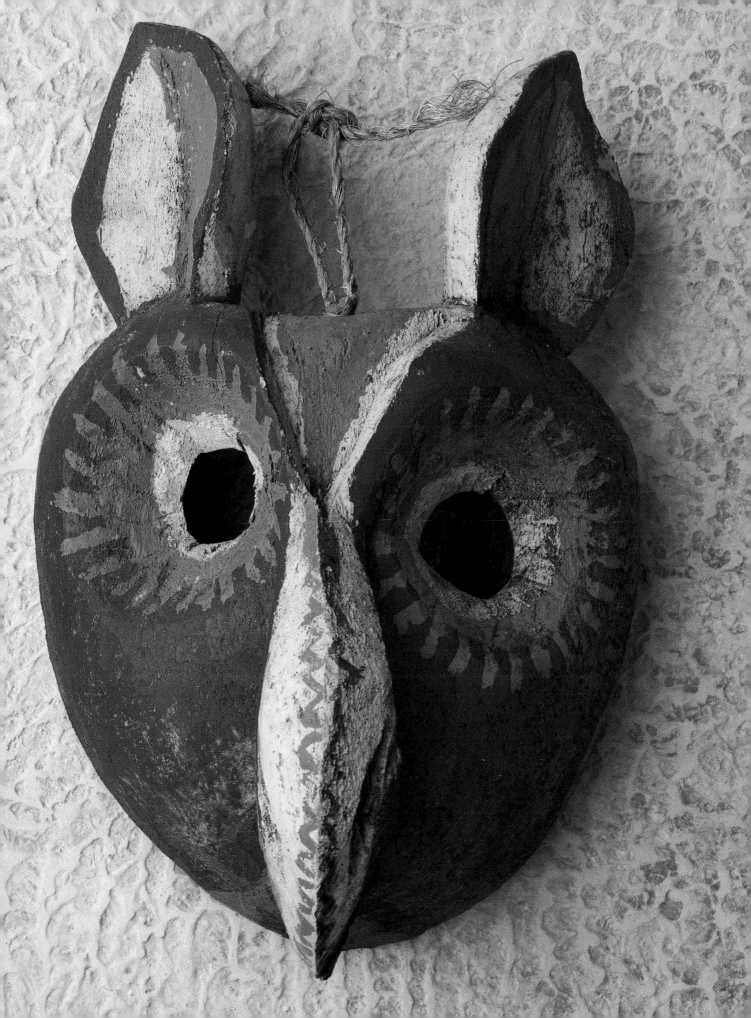

4 Bible, Devil – and Death

Although Conquest missionaries placed tremendous emphasis on imparting the Catholic religion through theatrical representation, we find surprisingly few Biblical characters in the dance-dramas of modern Mexico. Of these, the apostle *Santiago* (St James) is the most popular. His first miraculous appearance was in 1276 in Spain: seen in the sky during a battle against the Moors, he helped the Spaniards to victory. In 1531 in Mexico *Santiago* was again credited with a miracle. While the Christians were fighting a group of unconquered Indians, the apostle appeared in the sky next to the Holy Cross and stopped the sun. When the Indians saw this portent, they fell on their knees and begged to be baptised.

The *conquistadores* revered *Santiago* as their patron saint and protector, and invoked his name before every battle. Soon he also won the devotion of Indian converts who were impressed to see this powerful figure portrayed on horseback in church paintings and sculpture. (Unknown in the New World before the Conquest, horses were at first accorded supernatural status by the various native peoples, who mistook horse and rider for a single divinity.)

In modern Mexico, *Santiago* retains an important role within the cosmic vision of many indigenous groups. Regarded with deep affection, he is frequently identified with the sun. During dances, the apostle's white charger is evoked by the head – and sometimes hind quarters – of a wooden horse attached to the performer's waist. In many versions *Santiago* wears no mask; only his horse and clothing set him apart from the other characters. In regions where he is masked, however, his features are suitably refined and serene. Also much represented in the wake of evangelization is *San Miguel* (St Michael). Dances recount his battle with one or several devils. Like *Santiago*, the archangel often appears without a mask; in parts of Guerrero, however, he uses a small mask, wears wings and carries a great sword in his hand.

During Holy Week the Passion is acted out in countless Indian villages and Mestizo towns, but masks are never worn by those who impersonate Jesus Christ or the Virgin Mary. The Judas character, by contrast, is often masked. In the Purépecha region of Michoacán, Judas is represented by as many as ten performers; over this sacred period they become all-powerful and impose their will on the community. As already described, Christ's persecutors are generally termed *judíos* (Jews) or *fariséos* (Pharisees). Usually masked, they are often present in large numbers throughout Holy Week.

Also recounted during Bible classes was the fight between David and Goliath. This is interpreted in the state of Tabasco by the Chontal inhabitants of Cúlico and Tecoluta (**97, 98**). On 24 December festivities are held in honour of the Jesus Child in the Maya village of Dzidnup, Yucatán. Performers take the roles of Abraham and Isaac, and sing hymns of praise in the church atrium. Their elongated wooden masks are among the very few that are worn unpainted in Mexico (**92, 93**).

Diablo (Devil) masks are as varied as the roles they typify. There are zoomorphic masks, and others that smile merrily. Some masks are so exquisitely finished that they recall European images. The Devil had no counterpart in the pre-Conquest world. Hell was an alien concept, because pre-Hispanic

87 *Judas* during Holy Week ceremonies in Erongarícuaro, Michoacán.
88 *Barrabás* during Holy Week ceremonies in El Doctor, Querétaro. Hat and mask of agglutinated, moulded cloth were made by Humberto Olvera. The mask attaches round the wearer's head with ties of cotton cloth.

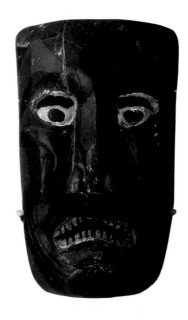

peoples did not believe that bad behaviour during life was punishable after death. They had no concept of absolute good or absolute evil, but recognized the dual nature of people and phenomena.

Although the Devil had little meaning for new converts, he was nevertheless represented in numerous allegories. Many of these dance-dramas survive to the present day. The Devil also appears frequently during *Carnaval* and Holy Week, and takes part in some versions of *los tecuanes* and *moros y cristianos*. In the Teloloapan region of Guerrero, during Independence celebrations, there is a contest for *diablos*: judges take into account both the inventiveness of masks and the gallantry shown to female bystanders. Dances within many cultures cast *el diablo* as a ceremonial buffoon: in this guise, he is frequently associated with *la muerte* (Death).

Deities with fleshless faces were common in pre-Christian Mexico. According to Aztec belief, most of those who died went to the underworld to abide with Mictlantecuhtli, Lord of the Dead. His role was not to reward virtue or punish sin. Because Mictlantecuhtli was not a vengeful god, he aroused little fear in the living. Today the character of *la muerte* participates in a great many dances, yet bears little relation to the pre-Hispanic deity. In fact, the roles assigned to *la muerte* have much in common with those played by *el diablo*, and both appear frequently together. Like the Devil, Death often performs as a ceremonial buffoon. It would be easy – but very wrong – to imagine that skull masks all look the same. While some are white, others are coloured; some are serious, but others are laughing. In short, there are as many facial expressions as there are representations of Death.

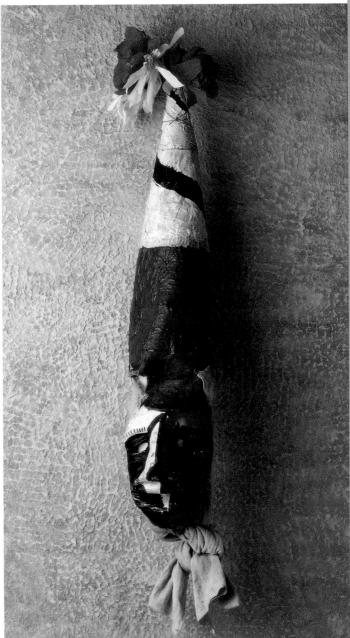

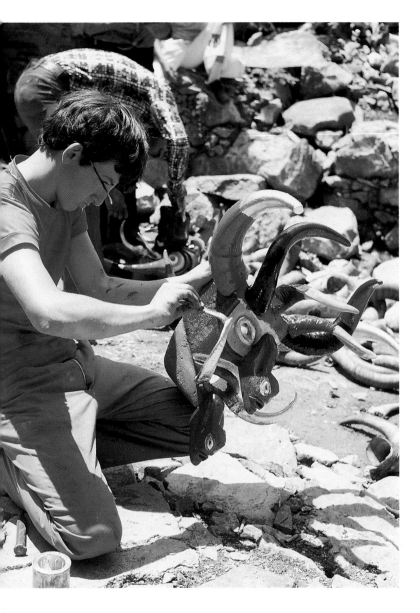

89 Mask-maker Fidel de la Fuente Jr. in 1976 in Teloloapan, Guerrero. He is finishing a *diablo* mask before *la mojiganga de los diablos* (Devils' Masquerade); this contest takes place on 16 September (Mexican Independence Day).

90 *Diablo* from *la mojiganga de los diablos* in Teloloapan, Guerrero. Fidel de la Fuente Sr. has used wood, commercial gloss paint, sheepskin and a single mirror. The central head is equipped with real teeth and the horns of a goat, a cow and a bull. The smaller heads have horns made from teeth. This extremely heavy mask is padded with felt inside to protect the wearer's face.

91 *Judío* during Holy Week ceremonies in 1977 in the Otomí community of El Doctor, Querétaro. The performer wears a mask·of agglutinated, moulded cloth.

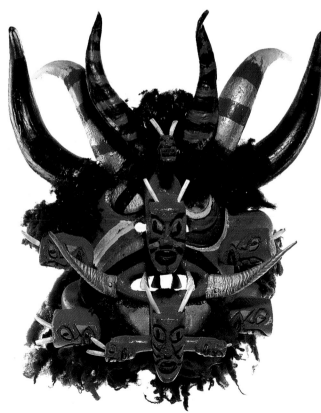

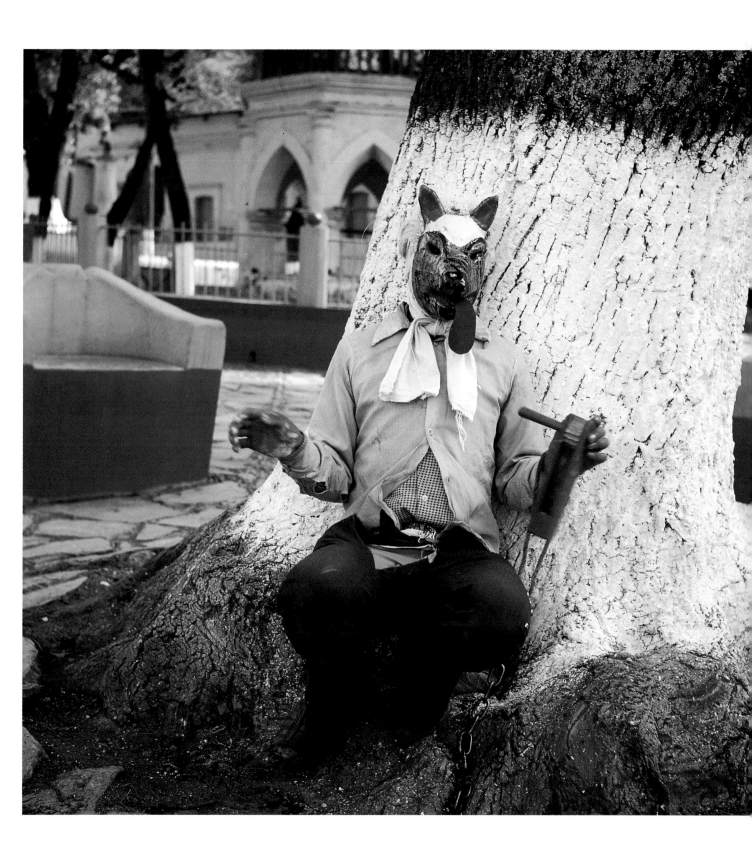

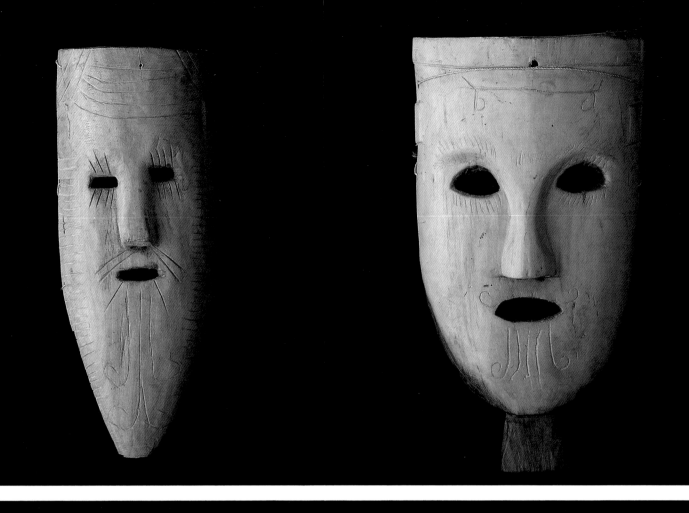

92, 93 Abraham (**92**/left) and Isaac (**93**/right). Of unpainted wood, these masks are worn during Christmas Eve celebrations in the Maya village of Dzidnup, Yucatán.
94 *Santiago* (St James) from the dance of *los santiagueros*. This mask was carved by Ruperto Abrajám in the Nahua community of Tixtla, Guerrero.
95 *Santiago* from the dance of *moros y cristianos* (Moors and Christians) in the state of Guerrero.

96 *Santiago* from the dance of *los archareos* (also *alchareos*). Mask and helmet were made by Juan Gómez Alcibar of San Martín de las Pirámides, Mexico State. The mask is of resin and fibreglass; the tin helmet features a cross and rays of light.

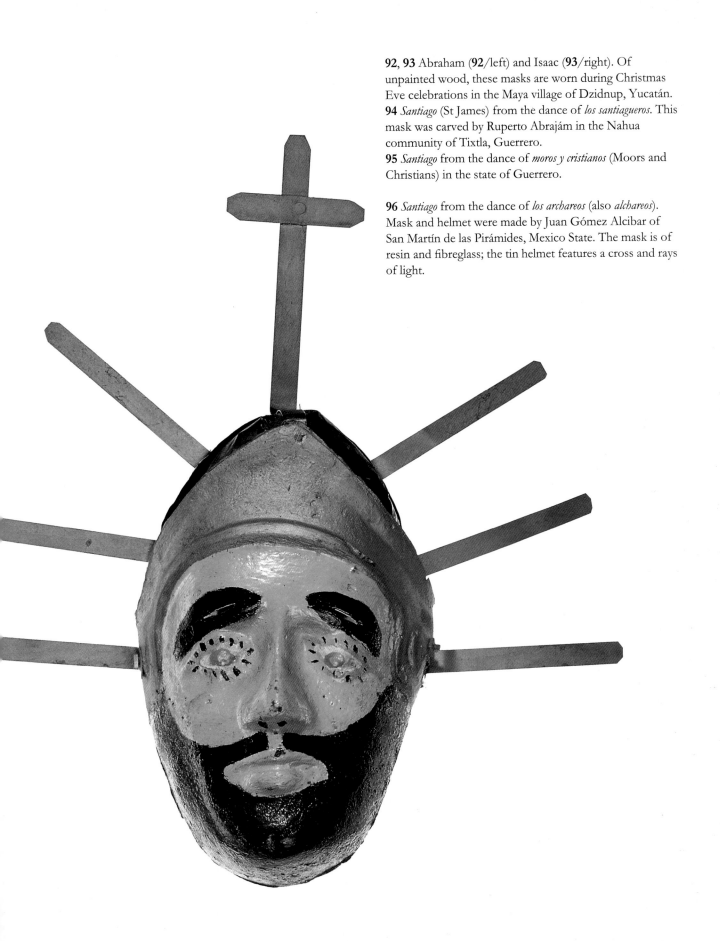

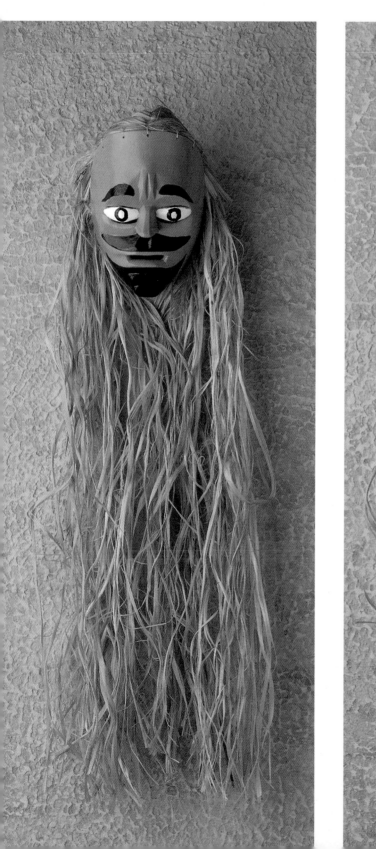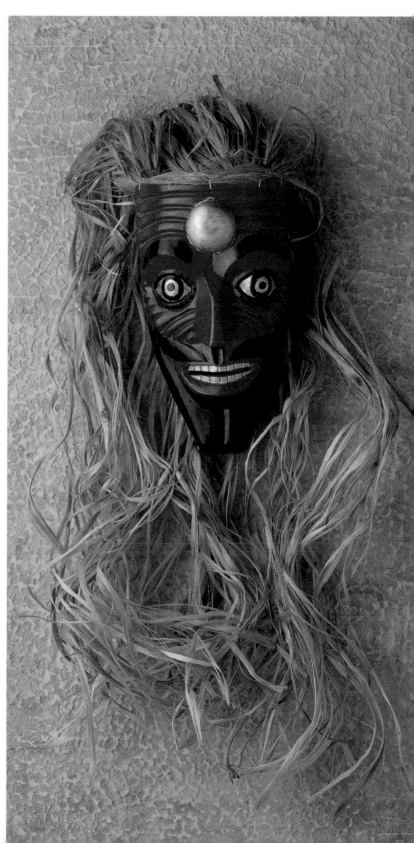

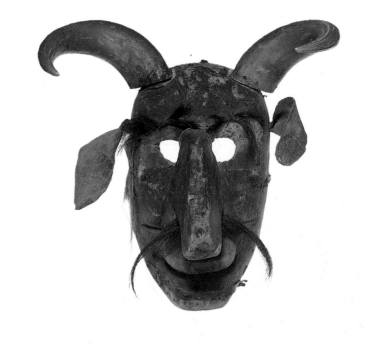

97, 98 David (**97**/left) and Goliath (**98**/right) from the Chontal community of Tecoluta, Tabasco. Both masks were carved by Macario de la Cruz for the dance known simultaneously as *baila-gigante* and *el gigante Goliat*. Performers wear wigs of *jolosín* (bark strips from the *jonote* tree).

99 *Diablo* (Devil) for Holy Week ceremonies from the Pame community of Ciudad Maíz, San Luis Potosí. The mask-carver has added cow or bull horns, horsehair and ears of leather. The beard (now missing) was secured by a leather strip.

100 *Diablo* for Holy Week ceremonies from Río Verde, San Luis Potosí. Such masks were worn in the past by Pame inhabitants. The maker has used a printed tin can and cattle horns.

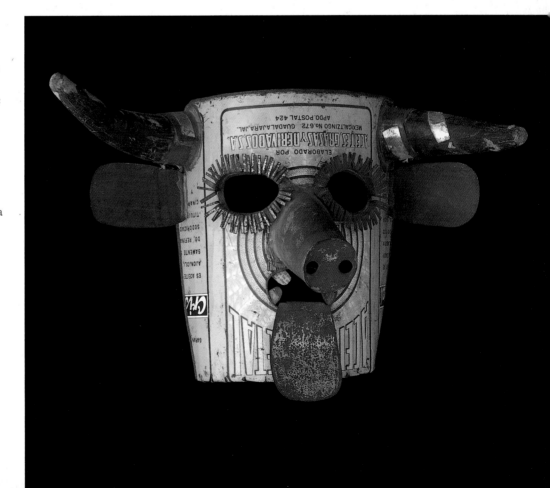

Devil masks are as varied as the roles they typify. Among the many different facial expressions there are few that inspire terror.

101 *Diablo* from Corrales, Guanajuato. Probably worn during the *pastorela* (Christmas dance-drama), this mask incorporates a pig's snout, a snake on top of the head, and a lizard down one side of the face. Over the years, it has received several layers of paint.
102 *Diablo* from the *pastorela* performed in Santa Gertrudis, San Luis Potosí. The mask-carver has added horsehair, real teeth, leather ears and a cloth tongue.

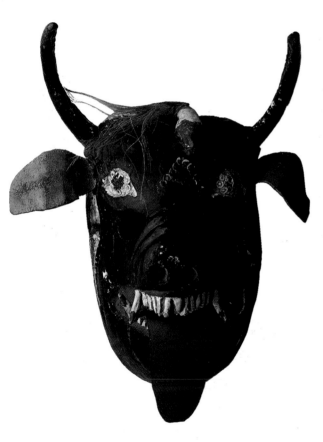

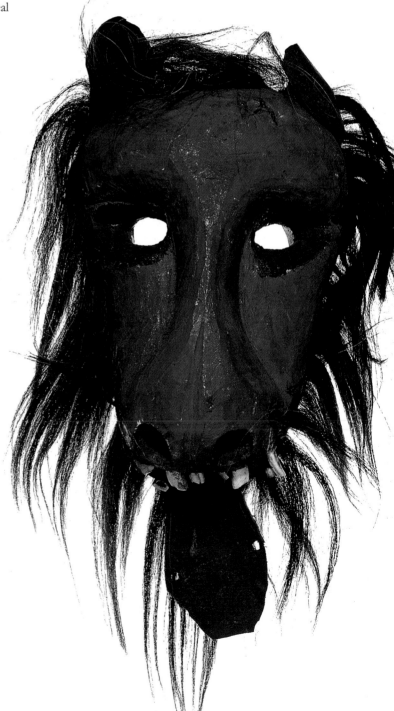

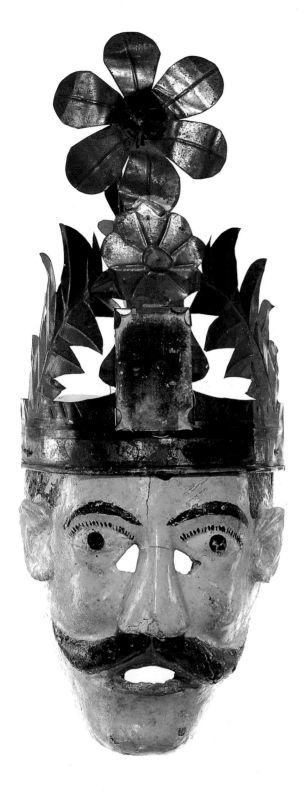

Masks representing *Luzbel* (Lucifer) are often very lovely. Before his fall from grace, *Luzbel* was characterized by great physical beauty.

103 *Luzbel* from a *pastorela* performed in Guanajuato State. The tin crown, partially painted and inset with a mirror, is more recent in date than the mask.

104 *Luzbel* from the dance of *los diablos* performed by Nahua villagers near Iguala, Guerrero.

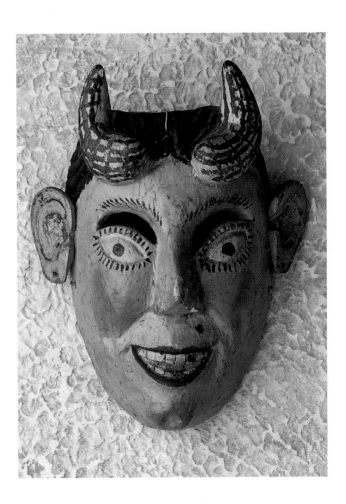

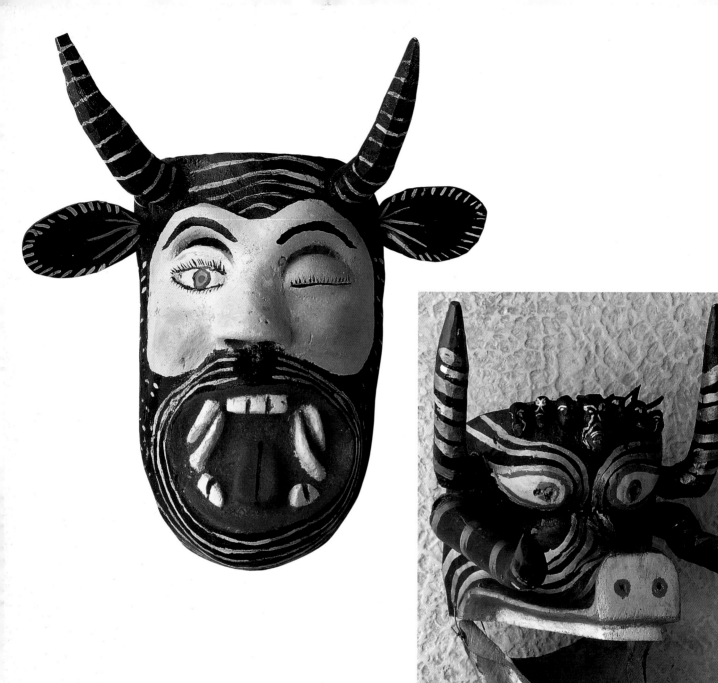

105 *Diablo*, with rubber ears, from the Purépecha village of Ocumicho, Michoacán. This mask was carved for the *pastorela* by Benjamin Campos Zamora.

106 *Diablo* from the Purépecha community of Tacuro, Michoacán. Worn during the *pastorela*, this mask has two pairs of horns, a movable jaw and a piglike snout. Seven small devils along the forehead represent the Seven Deadly Sins.

107 *Diablo* from the Mestizo community of El Pueblito, Querétaro. The mask-carver, Adolfo Zuñiga, has added goat horns and a cloth tongue. The dance of *los adultos* (Adults) is performed eleven days before *Carnaval*.

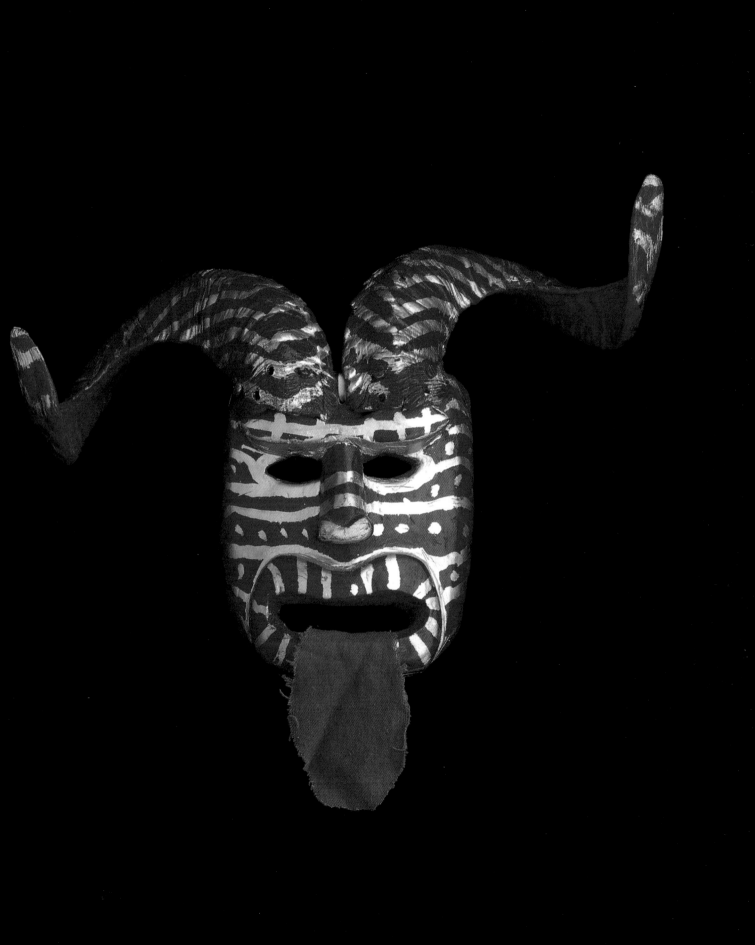

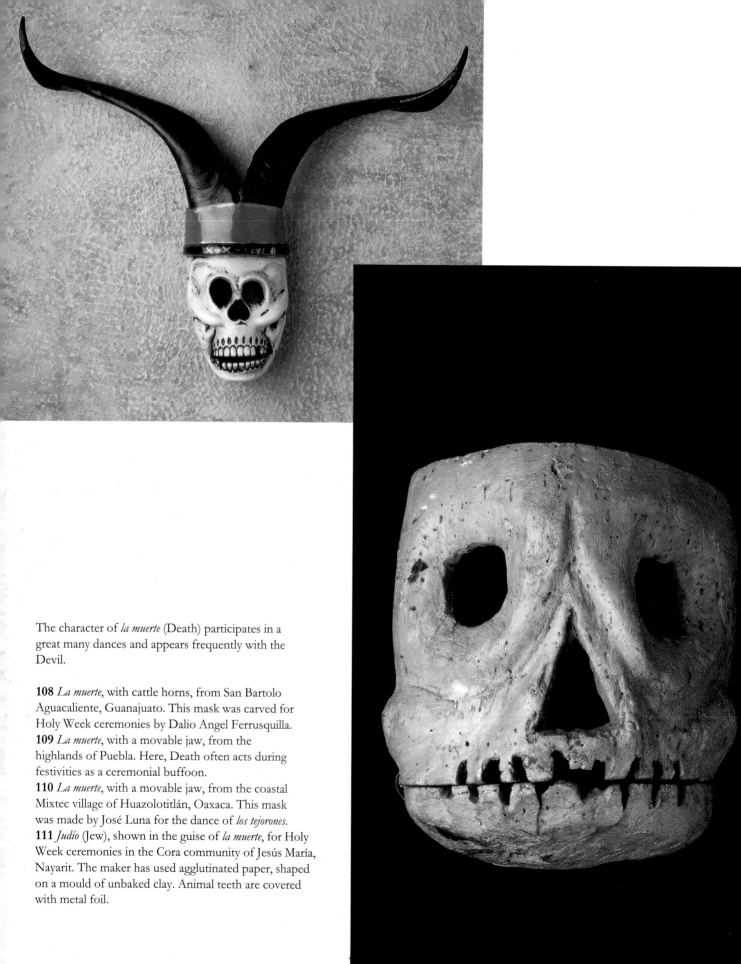

The character of *la muerte* (Death) participates in a great many dances and appears frequently with the Devil.

108 *La muerte,* with cattle horns, from San Bartolo Aguacaliente, Guanajuato. This mask was carved for Holy Week ceremonies by Dalio Angel Ferrusquilla.
109 *La muerte,* with a movable jaw, from the highlands of Puebla. Here, Death often acts during festivities as a ceremonial buffoon.
110 *La muerte,* with a movable jaw, from the coastal Mixtec village of Huazolotitlán, Oaxaca. This mask was made by José Luna for the dance of *los tejorones.*
111 *Judío* (Jew), shown in the guise of *la muerte,* for Holy Week ceremonies in the Cora community of Jesús María, Nayarit. The maker has used agglutinated paper, shaped on a mould of unbaked clay. Animal teeth are covered with metal foil.

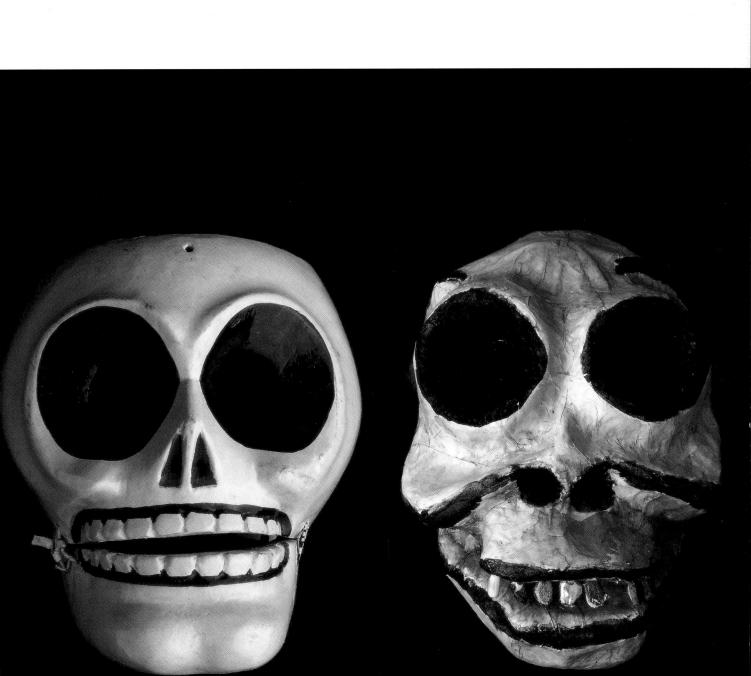

5 From Abstract to Fantastic

After the introduction of Christianity, Spanish colonists embarked on the destruction of stone idols and other symbols of 'pagan' religion. Mexico's newly conquered peoples were ordered to abandon their ancient gods, denounced as 'demons' by zealous friars. During this period of intense evangelization, pre-Hispanic deities were often represented in mask form: by adding horns and other 'demonic' attributes, Indians were free to honour their own gods with the compliance of unsuspecting missionaries.

Centuries passed and the old gods were eventually forgotten, but many contemporary masks retain visual associations with the pantheon of pre-Conquest civilizations. Tlaloc, the rain god, was commonly portrayed with a serpent encircling his eyes and with the gigantic fangs of a viper. Today, this description applies to numerous masks worn by *el diablo*. Representations of Ehecatl, the wind god, often showed him with the enormous beak of a bird projecting from his face. Modern mask traits reminiscent of Ehecatl include a disproportionately wide mouth, protruberant lips pursed as if whistling or, albeit rarely, a clearly defined beak. Tezcatlipoca was a very powerful nocturnal god whose colours were black and red; now these same colours are frequently applied to *diablo* masks.

Within the Aztec empire the most important military orders were those of the Eagle Knights and the Jaguar Knights. Warriors wore a special costume made from fine feathers or skins, and looked out through the wide-open beak or jaws of zoomorphic helmets. This custom is commemorated by contemporary masks which are in fact double: both the features of

the animal and the human face behind are carved in wood (**114–16**).

The word *chilolo* means 'mask' in the language of the Mixtec people. The dance of the *chilolos* is performed in several Mixtec villages in the highlands of Oaxaca, and consists of simulated battles. Betty Ann Brown, in an essay from *Máscaras: Dance Masks of Mexico and Guatemala*, describes events in Juxtlahuaca, Oaxaca: 'Although the *chilolos* wear European clothes, their ankles are ringed with bells and their hats topped with tall plumes. Similar bells and plumes are seen in images of pre-Columbian dances. In addition, their red masks are of a fixed form which has questionable significance if given an European interpretation: the curving tusk-like projections probably depict a pre-Conquest Mixtec character. The shape of the mask, too, is unlike those manifesting European influence. Having a short trapezoidal form with a deep shelf under the chin and protruding globular eyes, it contrasts with the naturalism of more hispanized examples.' The appearance of *chilolo* masks is equally strange and unrealistic in the Mixtec village of Yanhuitlán, where they also have bulging eyes and projections on the cheeks (**117**). Here, makers partially decorate these masks with *chapopote* (pitch), a substance much used for painting in pre-Hispanic times.

Chilolo masks and dances are almost certainly of pre-Christian origin, and may retain something of their ancient significance. The masks described earlier, however, exhibit only the outward traits of ancient gods: today they are worn by *diablo* performers in *pastorelas*, by characters from *Carnaval*, or during dances to honour the local patron saint.

112 *Viejo* (Old Man) from the dance of *los tejorones* during *Carnaval* in Pinotepa de Don Luis, Oaxaca. Fishlike features are combined with human features.
113 *Pascola* (Old Man of the Feast) from the Yaqui community of Potam, Sonora.

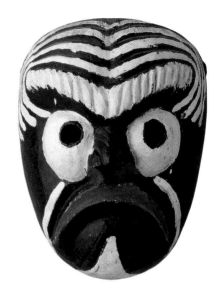

Some characters in contemporary Mexican dances represent wholly abstract concepts. Time, for example, can be portrayed in various ways. Shown on page 83 is a highly original interpretation incorporating three faces. The creator, Herminio Candelario, has no knowledge of Cubism and has never seen a reproduction of Picasso's work; his vision is entirely personal, without outside inspiration. The dance of *los siete vicios* (Seven Vices) is widely performed throughout the state of Guerrero. It is difficult to give a concrete form to the notions of pride, covetousness, lust, anger, gluttony, envy and sloth, but mask-carvers often show considerable wit. By combining two or more elements which are commonly zoomorphic – or, more rarely, anthropomorphic – they evoke the basic shape of a face.

Many *diablo* masks have human or animal faces overlaid with small reptiles and other creatures. In most cases the symbolism is unclear. Equally surreal are masks which perfectly imitate the human face: painted overall with unlikely colours, however, they feature a range of painted animals in contrasting hues. Some masks represent faces, yet are so fantastic in style as to be neither human nor animal: the beings portrayed exist only in the culture that gave them life and in the mind of the maker. Often, creations are governed by the natural forms of the materials used: a strangely shaped piece of wood with five added goat horns gives the impression of a hand (**132**). Masks in this section display immense vigour and expressive power. By exploiting available materials with ingenuity and artistry, makers communicate the spiritual and the abstract. Ritual dance masks embody the mysticism and tradition of countless centuries.

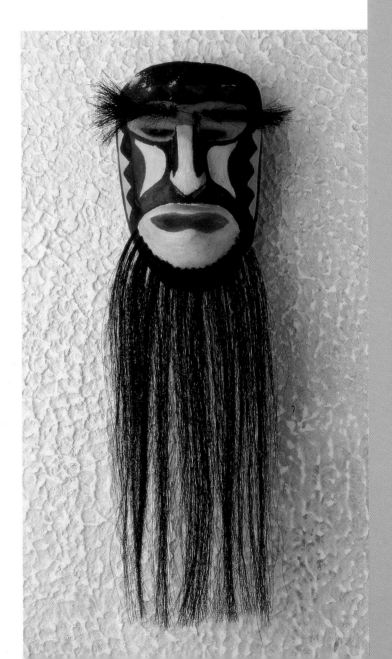

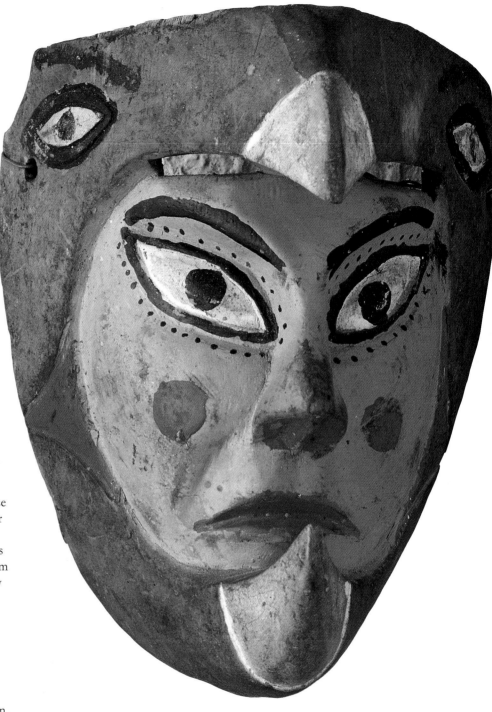

Within the Aztec empire the most important military orders were those of the Eagle Knights and the Jaguar Knights. Warriors looked out through the wide-open beak or jaws of zoomorphic helmets. This custom is commemorated by contemporary masks.

114 *Caballero aguila* (Eagle Knight) for *Carnaval* from the Otomí community of Huayacocotla, Veracruz.
115 *Caballero tigre* for *Carnaval* from the Otomí community of Silacatipan, Veracruz. Although the pre-Hispanic order of the Jaguar Knights comprised only male warriors, the mask-maker has here portrayed a female warrior.
116 *Caballero tigre* for *Carnaval* from Huayacocotla, Veracruz.

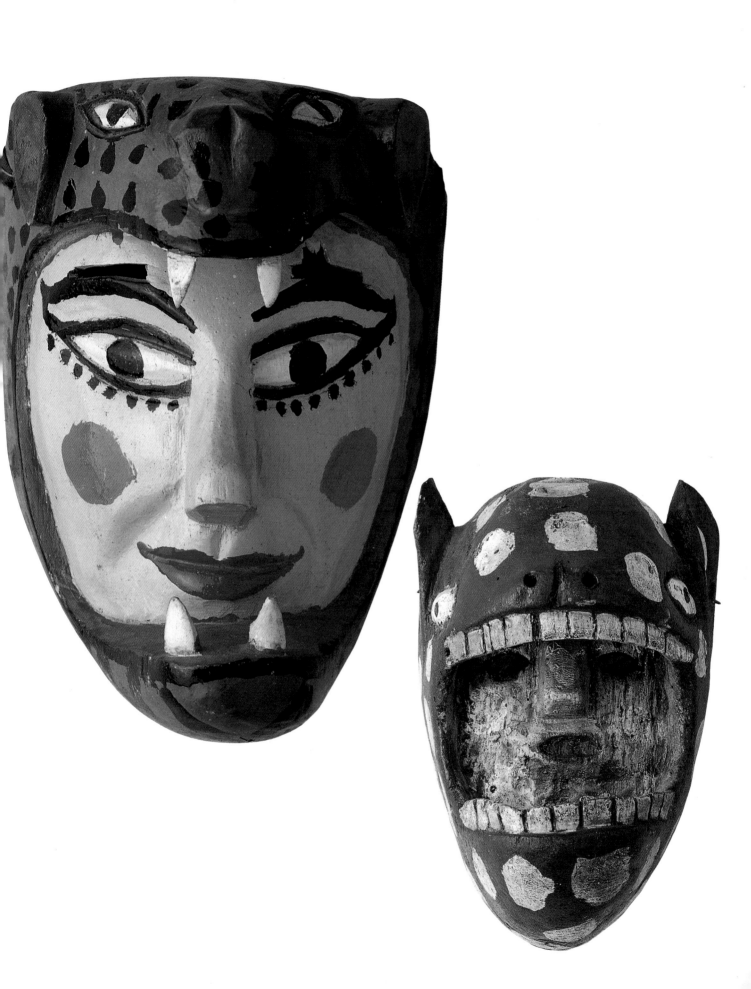

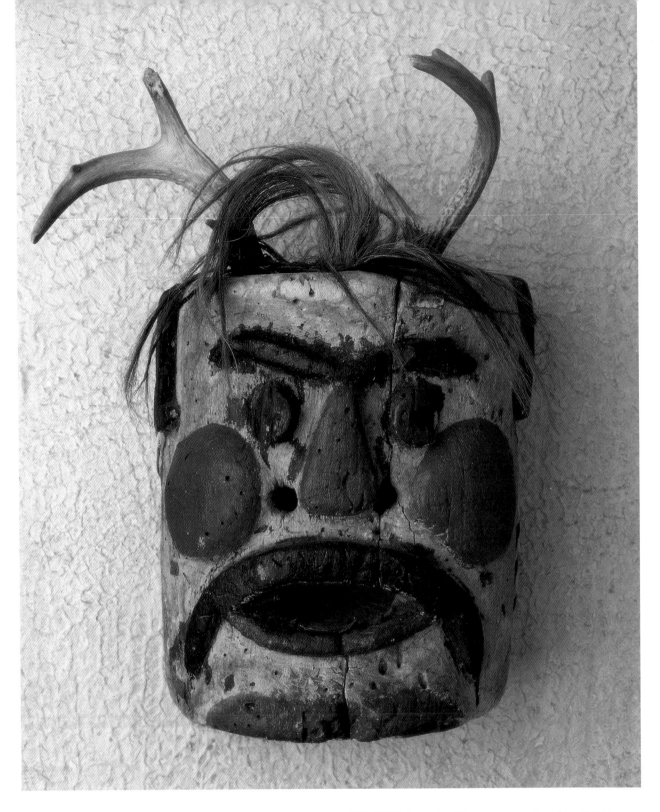

117 *Chilolo* from the Mixtec community of Yanhuitlán, Oaxaca. This mask was made by Felix Soriano Carisosa for use during yearly festivities in honour of the patron saint. The size exceeds that of the dancer's face. Because *chilolo* dancers engage in battle, hitting one another fiercely, masks deteriorate fast..

118 *El tiempo* (Time) from the Nahua community of
Suchitlán, Colima. Carved by Herminio Candelario for use
during the *pastorela* (Christmas dance-drama), this mask has
four eyes, three noses and three mouths to give the
impression of three faces. The wearer looks through eyes
in the centre.

Many Devil masks have human or animal faces; these may be overlaid with small reptiles and other creatures.

119 *Diablo* from the Nahua community of Chapa, Guerrero. This mask was carved by Santiago Martínez Delgado for use on 16 September and other festive occasions. The top of the nose takes the form of a human face. The dancer moves the tongue, which is carved in the shape of a human figure, by moving his own tongue.

120 *Diablo* from the *pastorela* of San Francisco (Municipio de Puruándiro), Michoacán. The Devil is shown here with an animal's face. Carved in high relief are four lizards (two on the forehead and two under the chin) and three serpents.

121 *Diablo* from the *pastorela* in the Nahua community of Suchitlán, Colima. Carved by Herminio Candelario, this mask displays two pairs of eyes (both slanting and round), painted scorpions on the cheeks, and twin snakes framing the face.

122 *Diablo* for various dances in the region of Iguala, Guerrero. Unusual traits include the distorted mouth and the lizard on the forehead.

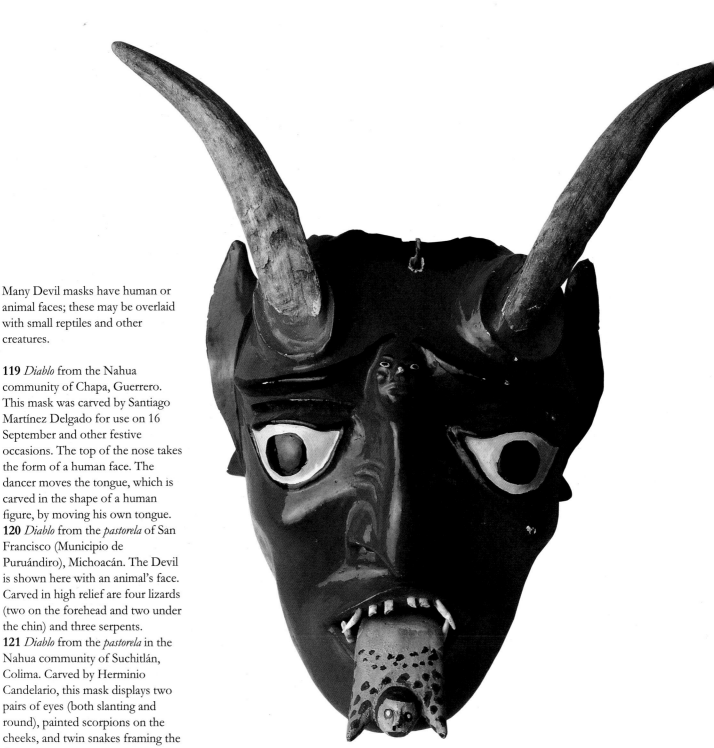

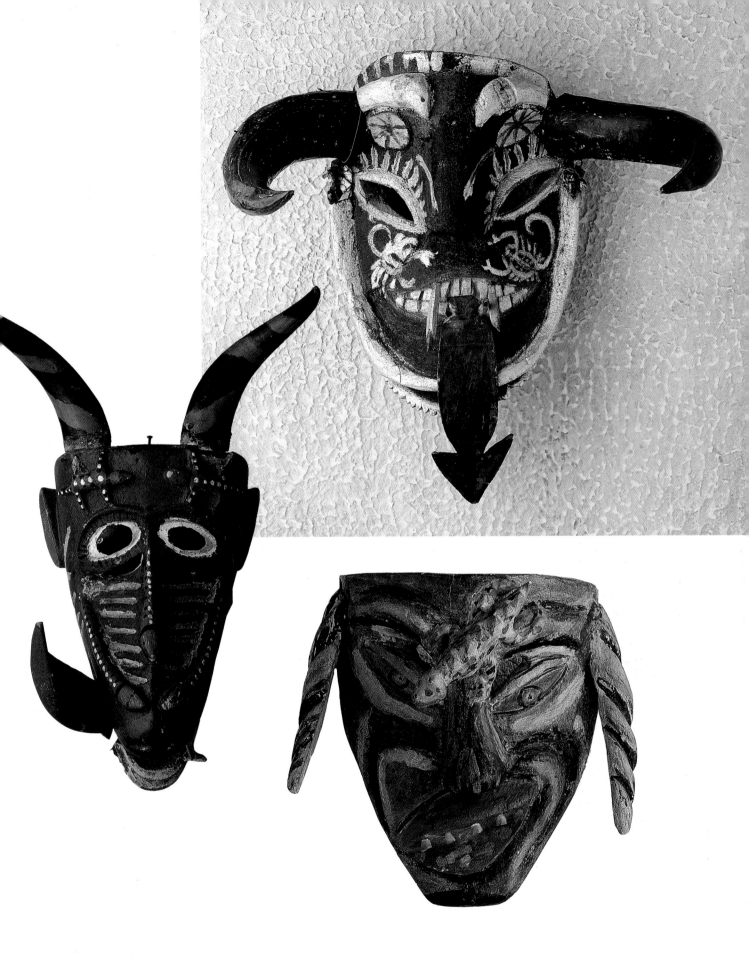

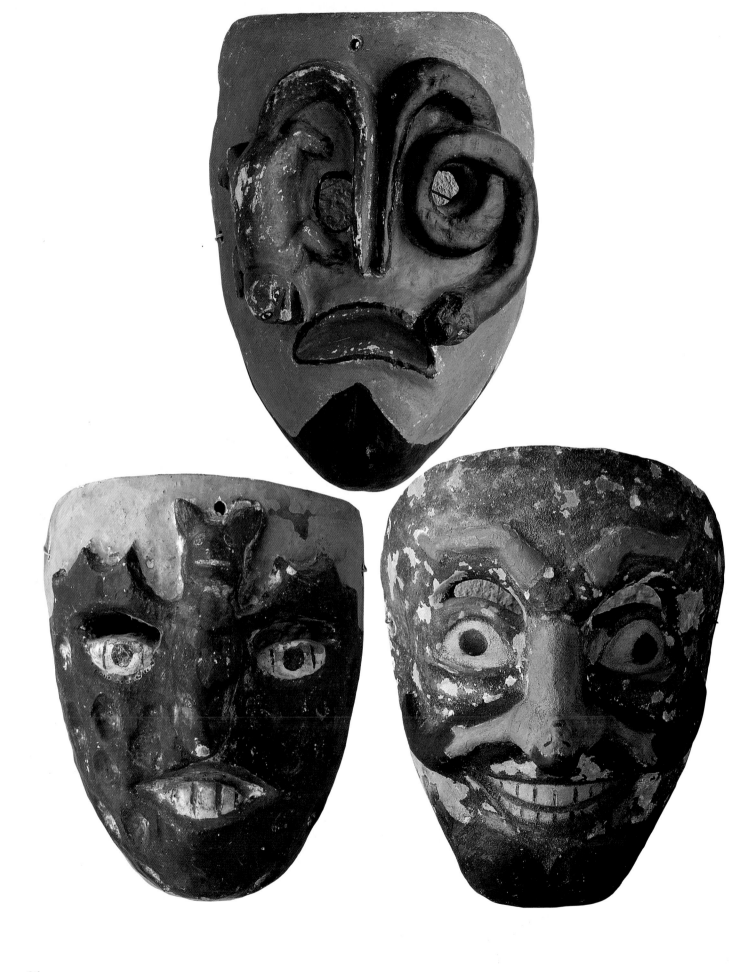

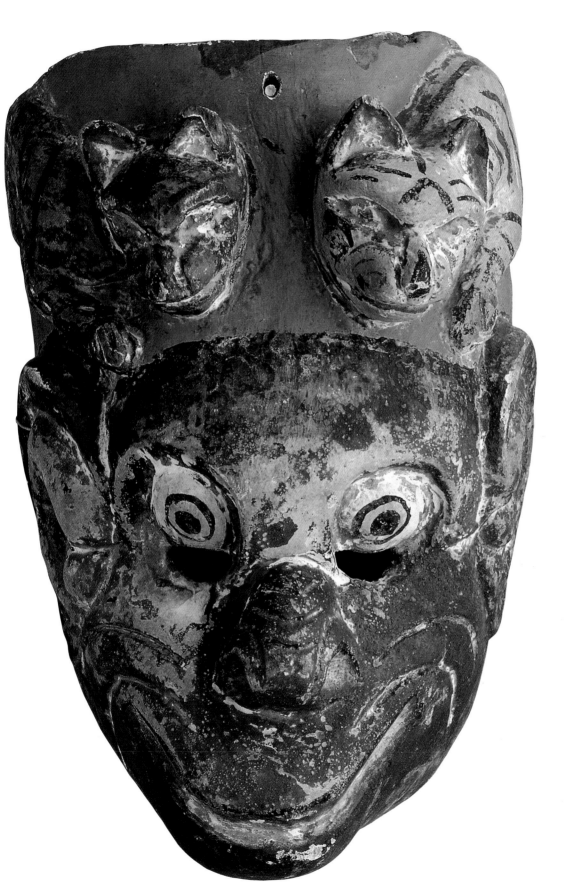

Highly inventive masks are worn in the state of Guerrero for *la danza de los siete vicios* (Dance of the Seven Vices). As they deteriorate with use, masks are re-painted by the maker or the performers.

123 Nahua mask from Guerrero State. A salamander and a serpent have been carved in high relief.
124 Nahua mask from Tixtla, Guerrero. The maker, Nolberto Abrajám, has combined the form of a bat with a human face; the bat's body serves as a nose.
125 Nahua mask carved by Nolberto Abrajám of Tixtla, Guerrero. A human body forms the nose on a human face; outstretched arms and legs serve as eyebrows and moustache.
126 Nahua mask carved by Nolberto Abrajám of Tixtla, Guerrero. Two *tigres* are shown above the face of a monkey.

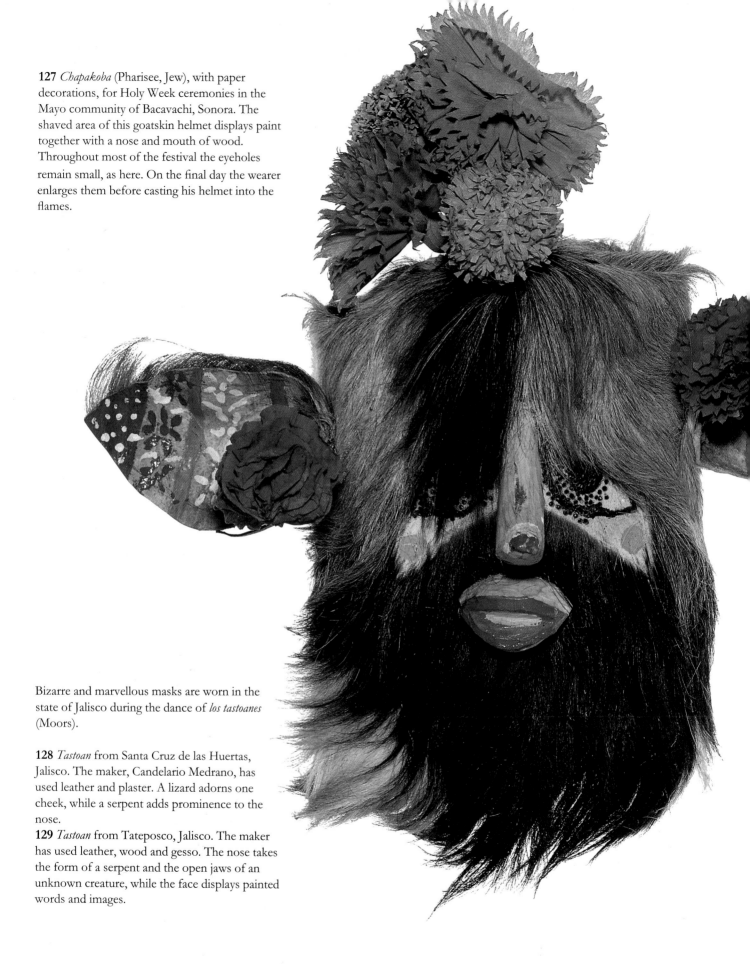

127 *Chapakoba* (Pharisee, Jew), with paper decorations, for Holy Week ceremonies in the Mayo community of Bacavachi, Sonora. The shaved area of this goatskin helmet displays paint together with a nose and mouth of wood. Throughout most of the festival the eyeholes remain small, as here. On the final day the wearer enlarges them before casting his helmet into the flames.

Bizarre and marvellous masks are worn in the state of Jalisco during the dance of *los tastoanes* (Moors).

128 *Tastoan* from Santa Cruz de las Huertas, Jalisco. The maker, Candelario Medrano, has used leather and plaster. A lizard adorns one cheek, while a serpent adds prominence to the nose.
129 *Tastoan* from Tateposco, Jalisco. The maker has used leather, wood and gesso. The nose takes the form of a serpent and the open jaws of an unknown creature, while the face displays painted words and images.

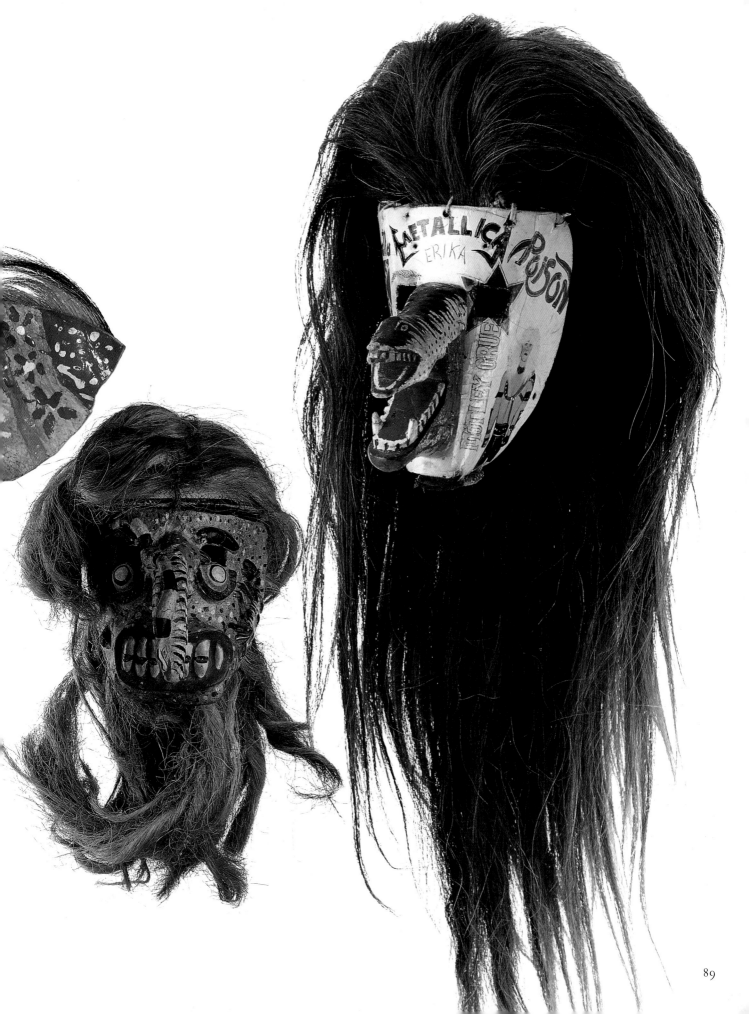

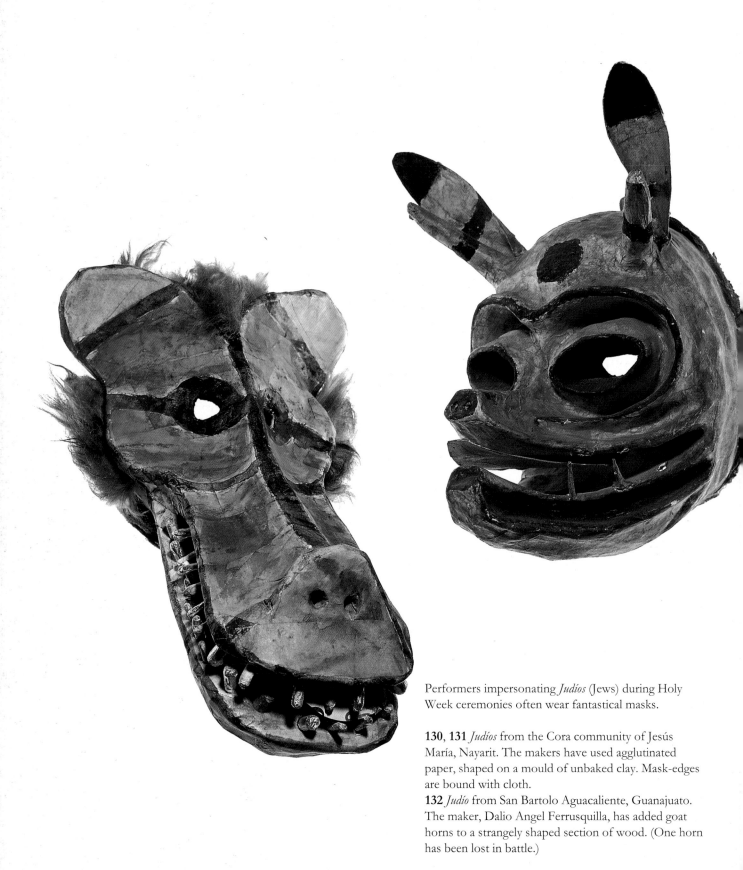

Performers impersonating *Judíos* (Jews) during Holy Week ceremonies often wear fantastical masks.

130, 131 *Judíos* from the Cora community of Jesús María, Nayarit. The makers have used agglutinated paper, shaped on a mould of unbaked clay. Mask-edges are bound with cloth.

132 *Judío* from San Bartolo Aguacaliente, Guanajuato. The maker, Dalio Angel Ferrusquilla, has added goat horns to a strangely shaped section of wood. (One horn has been lost in battle.)

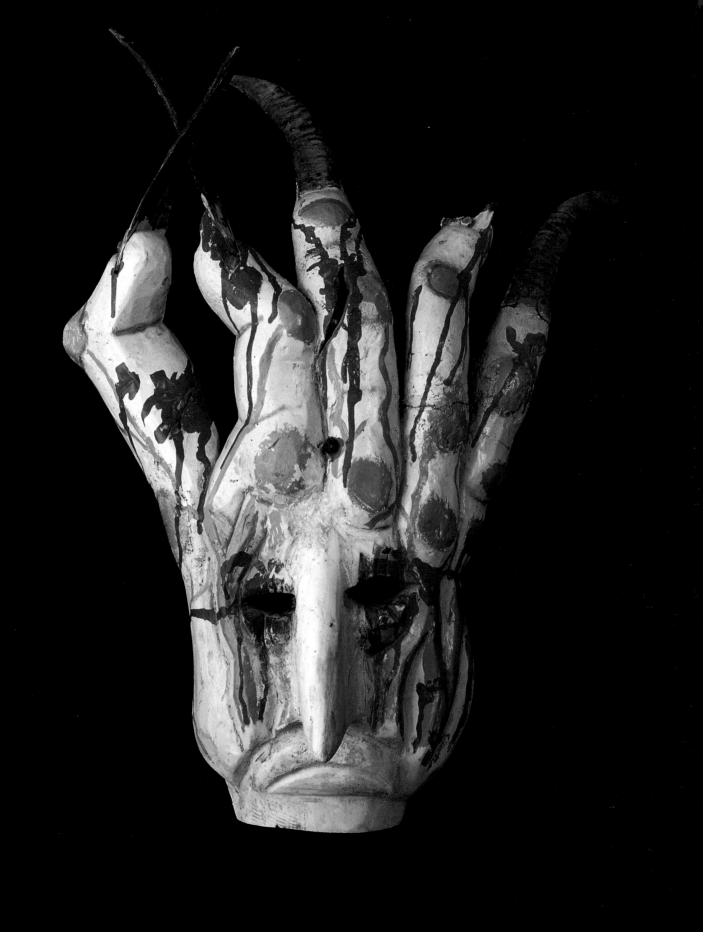

Notes on the Masks

All photographs are by David Lavender, except those credited to Ruth D. Lechuga

Half-title page Male dancer wearing female dress, *danza de los diablos*, Day of the Dead ceremonies. La Estancia Grande, Oaxaca. Inhabitants are of Black African descent. Mask and bust have been improvised with flexible cardboard. *Photo Ruth D. Lechuga.*

Title page Dog, *danza de los tlacololeros*. Ayahualulco, Guerrero. Nahua. Wood and commercial paint; the hat is of plaited palm. c. 1985. H (excluding hat) 8 in (20.3 cm).

Contents page (left to right) *Viejo de Carnaval.* Zontecomatlán, Veracruz. Nahua. Wood and water-based commercial paint. c. 1985. H 9½ in (24.1 cm).

Female character, *Carnaval.* Alto Lucero, Veracruz. Nahua. The mask-carver, Adulfo Castillo Aguilar, has used wood, gesso and commercial gloss paint. 1991. H 9¼ in (23.5 cm).

Monkey. This character appears during the ceremony to mark the change of *mayordomo* (religious dignitary). Tacuro, Michoacán. Purépecha. Wood and commercial paint. c. 1970. H 7¼ in (18.4 cm).

Diablo, pastorela. Río Verde, San Luis Potosí. Mestizo. Tin, commercial paint and sheepskin, with a cloth tongue and the horns of a bull or cow. The mask is lined with cloth. c. 1960. H (excluding horns) 13 in (33 cm).

Tastoan, danza de los tastoanes. Santa Cruz de las Huertas, Jalisco. Mestizo. Leather, plaster and commercial paint. Strands of partially dyed *ixtle* fibre are attached to a base of plaited palm. c. 1960. H (excluding hair) 7½ in (19 cm).

1 *La mula, danza de los caballitos broncos.* Ciudad Maíz, San Luis Potosí. Pame. The mask-maker has used a bottle-gourd and commercial paint; a second gourd forms the nose, while the eyelashes are of sheepskin. 1992. H 9 in (23.5 cm).

2 *Huezquistle*, various dances. Acatlán, Guerrero. Nahua. Wood, gesso, commercial paint and strands of dyed *ixtle* (agave fibre). c. 1950. H (excluding hair) 7 in (17.8 cm).

3 *Pescador, danza del pescado.* Quechultenango, Guerrero. Nahua. Wood and commercial paint. c. 1960. H 7¼ in (18.4 cm).

4 *Huehuentones*, Feast of the Patron Saint. Huehuetla, Puebla. Totonac. *Photo Ruth D. Lechuga.*

5 Various male characters, *Carnaval, pastorela* and other dances and festivals. Veracruz, Tlaxcala, Guanajuato, Michoacán and other states. Mestizo and indigenous. Wood, gesso and commercial paint. Various dates. Average H 7½ in (19 cm).

6 *Viejo de Carnaval.* Region of Huayacocotla, Veracruz. Otomí or Nahua. Wood and commercial paint. 1990. H 11¼ in (28.5 cm).

7 *Zapador, Carnaval.* Huejotzingo, Puebla. Mestizo. Moulded leather and paint, with a beard of human hair stretched over a wire frame. c. 1980. H (excluding beard) 7½ in (19 cm).

8 *Viejo, Carnaval.* Made in Santa María Astahuacán, Distrito Federal. Worn in Atenco, Chimalhuacán and other towns in Mexico State. Cotton cloth in beeswax, paint and dyed *ixtle* fibre. 1991. H (excluding beard) 7 in (17.8 cm).

9 *Chinelo, Carnaval.* Tepoztlán, Morelos. Mestizo. Wire-mesh, commercial paint and *ixtle* fibre. Edges are bound with cotton cloth. 1991. H 8¼ in (21 cm).

10 *Viejo, Carnaval.* Made in Santa María Astahuacán, Distrito Federal. Worn in Atenco, Chimalhuacán and other towns in Mexico State. Cotton cloth in beeswax, paint and *ixtle* fibre. 1975. H (excluding beard) 7 in (17.8 cm).

11 *Juan Tirador, danza de los tlacololeros.* Quechultenango, Guerrero. Nahua. Wood, gesso and commercial paint. c. 1945. H 9 in (22.8 cm).

12 *Viejo de Carnaval.* Zontecomatlán, Veracruz. Nahua. Wood and water-based commercial paint. c. 1985. H 8¾ in (22.1 cm).

13 *Viejo de Carnaval.* Region of Huayacocotla, Veracruz. Otomí or Nahua. Wood, gesso and several layers of commercial paint. Early 20th C. H 7½ in (19 cm).

14 *Juan Tirador.* Quechultenango, Guerrero (detail of **11**).

15 *Viejo de Carnaval.* Zontecomatlán, Veracruz (detail of **12**).

16 *Viejo de Carnaval.* Region of Huayacocotla, Veracruz (detail of **13**).

17 *Catrín, Carnaval.* Made in Tlatempan, Tlaxcala. Worn in Panotla and neighbouring villages in Tlaxcala. Mestizo. Wood, gesso and oil paint; the sheen was achieved with the stomach lining of cattle or poultry. The commercially made glass eyes have lashes of real hair. c. 1965. H 10 in (25.4 cm).

18 *Catrín, Carnaval.* Amaxac de Guerrero, Tlaxcala. Nahua. *Photo Ruth D. Lechuga.*

19 *Negro, la negrada.* Moyahua, Zacatecas. Mestizo. Wood, commercial paint and partially dyed *ixtle* fibre attached to the crown of a hat. c. 1971. H (excluding hair) 8½ in (21.6 cm).

20 *Negro, danza de los negritos and pastorela.* Ocumicho, Michoacán. Purépecha. Wood and commercial paint; the tin crown is decorated with *papelillo* (beads of paper-thin glass) and a mirror. c. 1985. H 6¾ in (17.1 cm).

21 *Negrito, danza de los negritos.* Uruapan, Michoacán. Mestizo. Lacquered wood; sheepskin headdress with ribbons, mirrors and *papelillo*. c. 1990. H (excluding headdress) 7½ in (19 cm).

22 *Ermitaño, pastorela.* Suchitlán, Colima. Nahua. Wood, commercial gloss paint and strands of *ixtle* fibre. c. 1985. H 9½ in (24.1 cm).

23 *Viejo, Carnaval* and Day of the Dead ceremonies. Region of Huejutla de Reyes, Hidalgo. Nahua. Wood and commercial paint. c. 1985. H 6½ in (16.5 cm).

24 *Viejo, danza de los tejorones, Carnaval.* San Juan Colorado, Oaxaca. Mixtec. Wood, gesso and commercial paint. c. 1960. H 5½ in (14 cm).

25 *Pascola*, Holy Week, weddings and Day of the Dead ceremonies. Region of El Fuerte, Sinaloa. Mayo. Wood, commercial gloss paint and cattlehair. c. 1965 H 7½ in (19 cm).

26 *Moro* or *archareo* (also *alchareo*), *danza de los archareos* (also *danza de los alchareos*). San Martín de las Pirámides, Mexico State. Mestizo. A moulded felt hat, commercial paint and sheepskin. 1991. H (excluding the sheepskin) 8 in (20.3 cm).

27 *Moro, danza de media luna.* San Felipe Tejalpa, Mexico State. Mestizo. Wood, gesso, commercial paint and eyelashes of real hair. c. 1950. H approx. 13 in (33 cm).

28 Male character, *danza de moros y cristianos.* Mexico State. Mestizo. Wood, gesso and commercial paint. c. 1950. H 10½ in (26.7 cm).

29 *Moro, danza de los santiagueros.* Cuetzalan, Puebla. Nahua. Wood and commercial paint. c. 1945. H 9 in (22.9 cm).

30 *Moro, danza de moros y cristianos.* Guerrero State. Probably Nahua. Wood, gesso and commercial paint. c. 1950. H 8¼ in (21 cm).

31 *Negra, danza de los locos.* Metepec, Mexico State. Mestizo. Painted pottery. The maker, Timoteo González, has used an old mould. c. 1980. H 8¼ in (21 cm).

32 *Vieja, danza del baila viejo.* Tecoluta or Nacajuca, Tabasco. Chontal. The maker, Macario de la Cruz, has used unpainted wood and strands of *jolosín* (bark strips from the *jonote* tree) attached to a palm base in the form of a skull cap. c. 1975. H (excluding hair) 8¾ in (22.2 cm).

33 *Maringuilla bonita, danza de los viejitos.* San Juan Nuevo, Michoacán. Purépecha. Wood, gesso and commercial paint; eyes painted on glass. 1991. H 7 in (17.8 cm).

34 *Maringuilla fea, danza de los viejitos feos.* San Juan Nuevo, Michoacán. Purépecha. Wood, gesso and commercial paint. 1991. H 7¾ in (19.7 cm).

35 *Soldadera francesa, Carnaval.* Huejotzingo, Puebla. Mestizo. Leather and commercial paint. c. 1980. H 8 in (20.3 cm).

36 Male dancer playing a female character, *Carnaval.* Tepeyanco, Tlaxcala. Nahua. The wooden mask is finely carved and painted. *Photo Ruth D. Lechuga.*

37 *Maringuilla, danza de los paragüeros. Carnaval.* Made in Puebla City. Worn in Papalotla and other Nahua communities in Tlaxcala. Wood, gesso, car paint, glass eyes and eyelashes of human hair. c. 1970. H 9 in (22.9 cm).

38 *Maringuilla bonita, danza de los viejitos.* Sevina, Michoacán. Purépecha. Wood, commercial paint, eyelashes of human hair and earrings. 1991. H 7½ in (19 cm).

39 *Maringuilla bonita, danza de los viejitos.* Ocumicho, Michoacán. Purépecha. Wood, commercial paint and earrings. 1991. H 7¼ in (18.4 cm).

40 *Viejita, danza de los viejitos.* Uruapan, Michoacán. Mestizo. Lacquered wood, animal teeth and *ixtle* fibre. c. 1990. H (excluding hair) 7½ in (19 cm).

41 *Vieja, danza de los huehues.* Apango, Guerrero. Nahua. Wood and commercial paint. c. 1985. H 8¾ in (22.3 cm).

42 *Vieja, danza de la tortuga (danza de los tejorones).* Huazolotitlán, Oaxaca. Mixtec. Wood, gesso and commercial paint. c. 1980. H 9½ in (24.2 cm).

43 *Vieja, danza de los manueles.* Tixtla, Guerrero. Nahua. Wood, gesso and commercial paint. c. 1940. H 7½ in (19 cm).

44 Comic female character, *Carnaval.* Barrio de San Ramón, San Cristóbal de las Casas, Chiapas. Mestizo. Paper and commercial gloss paint. 1990. H 8 in (20.4 cm).

45 *Bruja, danza de los tecuanes.* Acatlán, Puebla. Mestizo. Wood, gesso, commercial paint, animal teeth, *ixtle* fibre and cloth. c. 1980. H 12¼ in (31.1 cm).

46 *Bruja*, unknown dance. Sierra de Juárez, Oaxaca. Zapotec. Wood, gesso and commercial paint. c. 1920. H 7½ in (19 cm).

47 *La borracha, danza del torito.* Silao, Guanajuato. Mestizo. Wood, gesso, commercial paint and dyed *ixtle* fibre. c. 1940. H (excluding hair) 10½ in (26.6 cm).

48 *La borracha, danza del torito.* Cuerámaro, Guanajuato. Mestizo. Wood, gesso, commercial paint and dyed *ixtle* fibre. c. 1940. H (excluding hair) 11½ in (29.2 cm).

49 *La borracha, danza del torito.* Guanajuato State. Mestizo. Wood, gesso and commercial paint. c. 1950. H 10½ in (26.6 cm).

50 *La viuda, cuadrilla de los toreros, Carnaval.* Nezquipayac, Mexico State. Mestizo. Wood, gesso, commercial gloss paint, *ixtle* fibre, ribbons and a paper rosette. c. 1975. H (excluding hair) 9¾ in (24.8 cm).

51 *La Malinche*, various dances. Guerrero State. Nahua or Mestizo. Wood, gesso, commercial paint and dyed *ixtle* fibre. c. 1960. H (excluding hair) 10½ in (26.6 cm).

52 *La Malinche*, various dances. Acapetlahuaya, Guerrero. Nahua. Wood, gesso, various layers of commercial paint with a sealant of *chía* oil, and horsehair. c. 1950. H 6¾ in (17.1 cm).

53 *La Malinche*, various dances. Acatlán, Puebla. Mestizo. Wood, gesso, commercial paint and metal teeth. c. 1960. H 6¾ in (16.1 cm).

54 *Judío*, Holy Week. Tonichi, Sonora. Pima. Paper, cardboard and commercial gloss paint. c. 1985. H (excluding hat) 9 in (22.9 cm).

55 *Judío*, Holy Week. El Doctor, Querétaro. Otomí. Cloth, commercial gloss paint, sharp twigs for teeth and *ixtle* fibre. 1991. H (excluding hair) 8 in (20.4 cm).

56 *Judío*, Holy Week. El Doctor, Querétaro. Otomí. Cloth, commercial gloss paint and *ixtle* fibre. c. 1977. H (excluding hair) 9 in (22.9 cm).

57 *Chapakoba*, Holy Week. El Fuerte, Sinaloa. Mayo. Deerskin, wood, wire-mesh, commercial paint and paper. c. 1990. H 12 in (30.5 cm).

58 Monkey, *Carnaval.* Alto Lucero, Veracruz. Nahua. Wood and commercial paint. 1991. H 9¼ in (23.5 cm).

59 *La perra maravilla, danza de los tastoanes.* Santa Cruz de las Huertas, Jalisco. Mestizo. Leather, gesso and commercial paint with

ixtle fibre attached to a palm hat. c. 1980. L (excluding headdress) approx. 13½ in (34.3 cm).

60 *Viejo, danza de los viejos.* Cuilapan, Oaxaca. Mixtec. Wood, commercial paint and cowhair. c. 1970. H (excluding horns) 10½ in (26.6 cm).

61 *Macho cabrío, Carnaval.* El Nante, Hidalgo. Otomí. Wood, goat horns and goathair secured with a leather strip. c. 1965. H (excluding beard and horns) 7 in (17.8 cm).

62 Goat, *danza de los tejorones.* Pinotepa de Don Luis, Oaxaca. Mixtec. Wood, commercial paint and goat horns. c. 1980. H (including beard but excluding horns) 10½ in (26.6 cm).

63 Pig, *Mahoma de Cochi, Carnaval.* Ocozocuautla, Chiapas. Zoque. Wood, commercial gloss paint, leather ears, clear plastic over the eyes, and eyelashes of real hair. c. 1965. L 9½ in (24.1 cm).

64 Boarlike creature, unknown dance. Yaitepec, Oaxaca. Chatino. Wood and commercial paint. c. 1982. H 8¼ in (21 cm).

65 Dog, *danza de los tlacololeros* or *danza de los tecuanes.* Guerrero State. Nahua or Mestizo. Wood, gesso and commercial paint. c. 1975. H 12½ in (31.7 cm).

66 Dog, *danza de los tecuanes.* Acatlán, Puebla. Mestizo. Wood and commercial paint. c. 1980. H 9½ in (24.1 cm).

67 Alligator, *danza de los tejorones.* San Juan Colorado, Oaxaca. Mixtec. Wood, commercial paint and thorns. c. 1950. L 16¼ in (41.3 cm).

68 Lizardlike creature, *danza de los tejorones.* Huazolotitlán, Oaxaca. Mixtec. Wood, gesso and commercial paint. c. 1985. L approx. 12 in (30.5 cm).

69 Alligator, *danza de los tejorones.* Coastal region of Oaxaca State. Mixtec. Wood, gesso and commercial paint. c. 1980. L 13 in (33.1 cm).

70 Fish, *danza de los pescadores.* Tlacotepec, Guerrero. Nahua. Wood, gesso, commercial paint, animal teeth and leather. c. 1970. H 6 in (15.2 cm).

71 Fish, *Carnaval* and Day of the Dead ceremonies. Region of Huejutla de Reyes, Hidalgo. Nahua. Wood and commercial paint. c. 1985. H 9 in (22.9 cm).

72 Bull, *Carnaval.* Xico, Veracruz. Nahua. Wood, commercial gloss paint, and the horns of a bull. 1992. H (excluding horns) 8 in (20.3 cm).

73 Bull, Holy Week. Jesús María, Nayarit. Cora. Paper, cloth, aniline dyes and a naturally derived black colourant. c. 1970. H 18 in (45.7 cm).

74 Bull, *Carnaval*. Alto Lucero, Veracruz. Nahua. Wood, commercial paint, leather and a mirror; cloth-covered palm hat with mirrors, paper flowers and glitter. c. 1980. H (excluding headdress) 8½ in (21.6 cm).

75 *Tigre, batalla de los tigres*. Zitlala, Guerrero. Nahua. Leather, commercial paint, mirrors and boar's whiskers. c. 1950. H approx. 13 in (33 cm).

76 *Tigre, danza de los tejorones*. Yaitepec, Oaxaca. Chatino. Wood and commercial paint. c. 1982. H 9¼ in (23.5 cm).

77 *Tigre*, harvest celebrations. Atzacoaloya, Guerrero. Nahua. Wood, gesso, commercial paint, leather, mirrors, animal teeth, boar's whiskers and cloth. c. 1970. H 14¼ in (36.2 cm).

78 *Tigre, Carnaval*. Juxtlahuaca, Oaxaca. Mixtec. The dancer's painted wooden mask is equipped with a leather tongue. *Photo Ruth D. Lechuga*.

79 *Tigre*, Corpus Christi. Suchiapa, Chiapas. Mestizo. Wood, gesso, cloth and commercial paint. c. 1980. H (excluding cloth) 6 in (15.2 cm).

80 *Tigre, danza de los tejorones*. San Juan Colorado, Oaxaca. Mixtec. Wood, commercial paint, mirrors and horsehair. c. 1975. H 12¾ in (32.4 cm).

81 *Tigre, danza de los tecuanes*. Made in Ahuehuetitla, Puebla. Worn in Acatlán, Puebla. Mestizo. Wood, commercial paint and two animal teeth. c. 1965. H 15¾ in (40 cm).

82 *Tigre, danza de los tejorones*. Pinotepa Nacional, Oaxaca. Mixtec. Wood, gesso and paint. c. 1965. H 7½ in (19 cm).

83 *Tigre*, procession of *tigres*. Olinalá, Guerrero. Nahua. Lacquered wood, leather, animal teeth, boar's whiskers and clear plastic over the eyes. c. 1960. H 12 in (30.5 cm).

84 Owl, *pascola* dance. San Bernardo, Sonora. Guarijío. Wood, paint and goathair. 1993. H 8¼ in (21 cm).

85 Owl, unknown dance. Guerrero State. Probably Nahua. c. 1970. H 9 in (22.9 cm).

86 Owl, *danza de los animales* (also *danza de los morenos*). Suchitlán, Colima. Nahua. Wood and commercial paint. c. 1985. H 12½ in (31.7 cm).

87 *Judas*, Holy Week. Erongarícuaro, Michoacán. Purépecha. Wood, commercial paint and a sheepskin moustache. The mask is lined with foam-rubber. c. 1940. H 10 in (24.4 cm).

88 *Barrabás*, Holy Week. El Doctor, Querétaro. Otomí. Cloth and commercial paint. The hat is lined with felt and topped with paper flowers. c. 1980. H (excluding hat) 9½ in (24.1 cm).

89 Mask-maker Fidel de la Fuente Jr. before *la mojiganga de los diablos* on Mexican Independence Day. Teloloapan, Guerrero. Mestizo. *Photo Ruth D. Lechuga*.

90 *Diablo, mojiganga de los diablos*. Teloloapan, Guerrero. Mestizo. Wood, commercial gloss paint, sheepskin, teeth, cattle horns and a mirror. The interior is padded with felt. 1976. H (excluding horns and hair) 12 in (30.5 cm).

91 *Judío*, Holy Week. El Doctor, Querétaro. Otomí. The performer wears a mask of agglutinated, moulded cloth. *Photo Ruth D. Lechuga*.

92 Abraham, Christmas Eve celebrations. Dzidnup, Yucatán. Wood. c. 1975. H 15 in (38.1 cm).

93 Isaac, Christmas Eve celebrations. Dzidnup, Yucatán. Wood. c. 1975. H 12¾ in (32.4 cm).

94 *Santiago, danza de los santiagueros*. Tixtla, Guerrero. Nahua. Wood, gesso and oil paint. c. 1950. H 9 in (22.9 cm).

95 *Santiago, danza de los moros y cristianos*. Guerrero State. Wood, gesso and oil paint. c. 1910. H 12¼ in (31.1 cm).

96 *Santiago, danza de los archareos* (also *alchareos*). San Martín de las Pirámides, Mexico State. Mestizo. The mask is of resin and fibreglass; the helmet is of tin. Both are decorated with commercial gloss paint. 1991. H 11½ in (29.2 cm).

97 David, *baila-gigante* (also *el gigante Goliat*). Tecoluta, Tabasco. Chontal. Wood and commercial gloss paint; wig of *jolosín*. c. 1989. H (excluding hair) 9 in (22.9 cm).

98 Goliath, *baila-gigante* (also *el gigante Goliat*). Tecoluta, Tabasco. Chontal. Wood and commercial gloss paint; wig of *jolosín*. c. 1989. H (excluding hair) 11 in (27.9 cm).

99 *Diablo*, Holy Week. Ciudad Maíz, San Luis Potosí. Pame. Wood, paint, cow or bull horns, horsehair and leather. c. 1960. H (excluding horns) 10½ in (26.7 cm).

100 *Diablo*, Holy Week. Río Verde, San Luis Potosí. Pame. Tin with cattle horns. c. 1950. H (excluding horns) 8¼ in (21 cm).

101 *Diablo*, probably *pastorela*. Corrales, Guanajuato. Mestizo. Wood, gesso, commercial paint, sequins, goat horns and hair, a cloth tongue and leather ears. c. 1940. H (excluding horns) 11½ in (29.2 cm).

102 *Diablo, pastorela*. Santa Gertrudis, San Luis Potosí. Mestizo. Wood, commercial paint, horsehair, real teeth, leather ears and a cloth tongue. 1960. H (excluding horns and tongue) 11½ in (29.2 cm).

103 *Luzbel, pastorela*. Guanajuato State. Mestizo. Wood, gesso, tempera and varnish. The tin crown, inset with a mirror, is more recent in date than the mask. c. 1890 (mask). H (excluding crown) 9½ in (24.1 cm).

104 *Luzbel, danza de los diablos*. Region of Iguala, Guerrero. Nahua. Wood, tempera and sealant. c. 1955. H 9¼ in (23.5 cm).

105 *Diablo, pastorela*. Ocumicho, Michoacán. Purépecha. Wood, rubber and commercial paint. 1991. H (excluding horns) 9 in (22.9 cm).

106 *Diablo, pastorela*. Tacuro, Michoacán. Purépecha. Wood and commercial paint. c. 1970. H (excluding horns) 8 in (20.4 cm).

107 *Diablo, danza de los adultos*. El Pueblito, Querétaro. Mestizo. Wood, commercial gloss paint, goat horns and a cloth tongue. 1991. H (excluding horns and tongue) 7¾ in (19.7 cm).

108 *La muerte*, Holy Week. San Bartolo Aguacaliente, Guanajuato. Mestizo. Wood, gesso, commercial gloss paint and cattle horns. 1991. H (excluding horns) 11½ in (29.2 cm).

109 *La muerte*, various dances. Sierra de Puebla. Nahua or Totonac. The painted wood has been strengthened with a coat of glue. c. 1970. H 8¼ in (21 cm).

110 *La muerte, danza de los tejorones*. Huazolotitlán, Oaxaca. Mixtec. Wood, gesso, commercial paint and varnish. The movable jaw is secured with thongs of leather. c. 1991. H 8¼ in (21 cm).

111 *Judío* (Jew). Holy Week. Jesús María, Nayarit. Cora. Paper and home-made paints. (Black was achieved with the ashes of burnt maizecobs; pink with brazilwood.) Animal teeth are covered with metal foil; mask-edges are bound with cloth. 1975. H 10 in (25.4 cm).

112 *Viejo, danza de los tejorones, Carnaval*. Pinotepa de Don Luis, Oaxaca. Mixtec. Wood, gesso and commercial gloss paint. Lines on the forehead denote the wrinkles of old age. c. 1975. H. 7¼ in (18.4 cm).

113 *Pascola*, Holy Week, weddings and Day of the Dead ceremonies. Potam, Sonora. Yaqui. Wood, commercial paint and goathair. c. 1950. H. 7¼ in (18.4 cm).

114 *Caballero aguila, Carnaval*. Huayacocotla, Veracruz. Otomí. Wood and commercial paint. c. 1975. H 7 in (17.8 cm).

115 *Caballero tigre, Carnaval*. Silacatipan, Veracruz. Otomí. Wood and commercial paint. c. 1985. H 8½ in (21.6 cm).

116 *Caballero tigre, Carnaval.* Huayacocotla, Veracruz. Otomí. Wood and commercial paint. c. 1975. H 8½ in (21.6 cm).

117 *Chilolo*, yearly festivities for the patron saint. Yanhuitlán, Oaxaca. Mixtec. Wood, red paint, pitch, deer horns and goathair. The leather tongue is missing. c. 1975. H (excluding horns) 12½ in (31.7 cm).

118 *El tiempo, pastorela.* Suchitlán, Colima. Nahua. Wood and commercial paint. c. 1985. H 13½ in (34.3 cm).

119 *Diablo*, 16 September and other festive occasions. Chapa, Guerrero. Nahua. Wood, gesso, oil paint, animal teeth and goat horns. c. 1975. H (excluding horns) 8¼ in (21 cm).

120 *Diablo, pastorela.* San Francisco, Municipio de Puruándiro, Michoacán. Mestizo. Wood, gesso, commercial gloss paint and the horns of a cow or bull. c. 1950. H (excluding horns) 13 in (33 cm).

121 *Diablo, pastorela.* Suchitlán, Colima. Nahua. Wood, commercial paint, silver paint and cattle horns; tongue of leather. c. 1985. H (excluding horns) 11½ in (29.2 cm).

122 *Diablo*, various dances. Region of Iguala, Guerrero. Mestizo. Wood, gesso, commercial gloss paint and real teeth. c. 1945. H 12 in (30.5 cm).

123 Character from *la danza de los siete vicios*. Guerrero State. Nahua. Wood, gesso and commercial paint. c. 1960. H 12½ in (31.7 cm).

124 Character from *la danza de los siete vicios*. Tixtla, Guerrero. Nahua. Wood, gesso and commercial paint. c. 1945. H 8¼ in (21 cm).

125 Character from *la danza de los siete vicios*. Tixtla, Guerrero. Nahua. Wood, gesso and commercial paint. c. 1945. H 8½ in (21.6 cm).

126 Character from *la danza de los siete vicios*. Tixtla, Guerrero. Nahua. Wood, gesso and commercial paint. c. 1945. H 10½ in (26.7 cm).

127 *Chapakoba*, Holy Week. Bacavachi, Sonora. Mayo. Goatskin, paint and wood, with paper decorations. c. 1970. H (excluding flowers) 11 in (27.9 cm).

128 *Tastoan, danza de los tastoanes.* Santa Cruz de las Huertas, Jalisco. Mestizo. Leather, plaster and commercial paint. Strands of partially dyed *ixtle* fibre are attached to a base of plaited palm. c. 1970. H (excluding hair) 8½ in (21.6 cm).

129 *Tastoan, danza de los tastoanes.* Tateposco, Jalisco. Mestizo. Leather, wood, gesso and commercial paint. Strands of horsehair are attached to a base of plaited palm. c. 1992. H (excluding hair) 8 in (20.4 cm).

130 *Judío*, Holy Week. Jesús María, Nayarit. Cora. Paper, cloth, aniline paints and cactus hair; the teeth are covered with metal foil. c. 1975. L 16½ in (42 cm).

131 *Judío*, Holy Week. Jesús María, Nayarit. Cora. Paper, cloth and home-made paints. (Black was achieved with the ashes of burnt maizecobs; pink with brazilwood.) c. 1970. H (including ears) approx. 13 in (33 cm).

132 *Judío*, Holy Week. San Bartolo Aguacaliente, Guanajuato. Mestizo. Wood, goat horns and commercial gloss paint. 1991. H (excluding horns) approx. 16 in (40.7 cm).

Bibliography

Aguirre Beltrán, Gonzalo, *La población negra de México, 1519–1810*, Mexico City 1946

Barrera Vázquez, Alfredo *et al*, 'Mitos, ritos y hechicerías', *Artes de México* (No. 124, Año XVI), Mexico City 1969

Benítez, Fernando, *Los indios de México* (5 vols), Mexico City 1970

Brandes, Stanley, *Power and Persuasion: Fiestas and Social Control in Rural Mexico*, Philadelphia 1988

Bricker, Victoria, *Ritual Humor in Highland Chiapas*, Austin 1973

Brown, Betty Ann, *Máscaras: Dance Masks of Mexico and Guatemala*, Bloomington 1978

– 'Mixtec Masking Traditions in Oaxaca', *Arte Vivo: Living Traditions in Mexican Folk Art* (ed. James R. Ramsey), Memphis 1983

Caso, Alfonso, *The Aztecs: People of the Sun*, Norman, Oklahoma, 1958

– 'Una máscara azteca feminina', *México en el Arte* No. 9, Mexico City 1950

– *Reyes y reinos de la Mixteca* (2 vols), Mexico City 1977

Cordry, Donald, *Mexican Masks*, Austin 1980

Crumrine, N. Ross, *El ceremonial de Pascua y la identidad de los Mayos de Sonora (México)*, Mexico City 1974

Crumrine, N. Ross and Halpin, Marjorie (eds), *The Power of Symbols: Masks and Masquerades in the Americas*, Vancouver 1983

Delgadillo, Ma. Elena and Lavalle, Josefina, *Danza de varitas*, Mexico City 1985

Díaz del Castillo, Bernal, *The True History of the Conquest of New Spain* (trans. and annotated by A.P. Maudslay; 5 vols), London 1908–16

Duby, Gertrude, *Chiapas indígena*, Mexico City 1961

Durán, Fray Diego, *Historia de las indias de Nueva España e islas de la tierra firme* (ed. Angel Ma. Garibay; 2 vols), Mexico City 1967

Encyclopedia of World Art (vol. IX), London 1964

Esser, Janet Brody, *Faces of Fiesta: Mexican Masks in Context*, San Diego 1981

– *Máscaras ceremoniales de los tarascos de la sierra de Michoacán*, Mexico City 1984

– (ed.) *Behind the Mask in Mexico*, Santa Fe, N.M., 1988

Griffith, James S. and Molina, Felipe, *Old Men of the Fiesta: an Introduction to the Pascola Arts*, Phoenix 1980

Gutiérrez Casillas, Manuel, *Las artesanías populares de madera en México*, Mexico City 1981

Gutiérrez, Tonatiúh and Mompradé, Elektra L., 'Danzas y Bailes Populares', *Historia General del Arte Mexicano*, Mexico City 1976

Horcasitas, Fernando *et al*, *Lo Efímero y Eterno del Arte Popular Mexicano* (vol 2), Mexico City 1971

Jackobson, Lori and Fritz, Donald, *Changing Faces: Mexican Masks in Transition*, McAllen, Texas, l985

Kingsborough, Lord (Edward King), *Antiquities of Mexico* (9 vols.), London 1830–48

Landa, Fray Diego de, *Relación de las cosas de Yucatán* (trans., notes Alfred M. Tozzer), Papers of the Peabody Museum of American Archaeology and Ethnology 18, Cambridge, Mass., 1941

Lechuga, Ruth D., 'Investigaciones sobre la Máscara en México', *México Indígena*, Mexico City 1982

– *Máscaras tradicionales de México*, Mexico City 1992

– *Màscares de Mèxic: Col·lecció Rafael Coronel* (Catàleg), Barcelona 1993

León-Portilla, Miguel, *La filosofía náhuatl*, Mexico City 1979

Lévi-Strauss, Claude, *La Voie des Masques*, Paris 1979

Luna Parra de García Sáenz, Georgina and Romandía de Cantú, Graciela, *El paisaje de México en el mundo de la máscara*, Mexico City 1978

Matos Moctezuma, Eduardo, *The Great Temple of the Aztecs: Treasures of Tenochtitlan* (trans. Doris Heyden), London 1988

Montenegro, Roberto and Villaurrutia, Xavier, *Máscaras mexicanas*, Mexico City 1926

Morris, Walter F., *Máscaras de Chiapas*, Mexico n.d.

Motolinía (Toribio de Benavente), *Memoriales* (ed. Luis García Pimentel), Mexico City 1903

Moya Rubio, Víctor José, *Máscaras mexicanas*, Mexico City 1974

– *Máscaras: la otra cara de México*, Mexico City 1978

Ogazón, Estela, *Máscaras mexicanas*, Mexico City 1981

Olivera de V., Mercedes, *Las danzas y fiestas de Chiapas*, Mexico City 1974

Pérez, Bernardo, *Masken aus Mexico*, 1981

Pomar, María Teresa, *Danza-máscara y rito-ceremonia*, Mexico City 1982

Pozas Arciniega, Ricardo, *Chamula: un pueblo indio en los altos de Chiapas* (2 vols), Mexico City 1977

Reyes, Juan Carlos *et al*, *Música, danza y pastorelas populares de la región de Colima*, Colima, n.d.

Robelo, Cecilia A., *Diccionario de aztequismos*, Mexico City n.d.

– *Diccionario de mitología náhuatl* (2 vols), Mexico City 1980

Romero Salinas, Joel, *La Pastorela Mexicana: origen y evolución*, Mexico City 1984

Sahagún, Fray Bernardino de, *General History of the Things of New Spain* (trans. and eds Arthur J.O.Anderson and Charles Dibble; 13 parts), Santa Fe, N.M., 1950–82

Sánchez Flores, Francisco and Lavalle, Josefina, *Danzas fundamentales de Jalisco*, Mexico City 1975

Sepúlveda Herrera, María Teresa, *Catálogo de máscaras del Estado de Guerrero*, Mexico City 1982

Sodi, Demetrio *et al*, 'Máscaras', *Arte Popular Mexicano*, Mexico City 1975

Soustelle, Jacques, *Daily Life of the Aztecs on the Eve of the Spanish Conquest*, London 1963

Toor, Frances, *A Treasury of Mexican Folkways*, New York 1976

Torquemada, Fray Juan de, *Monarquía indiana* (ed. Salvador Chávez Hayhoe), Mexico City 1943

Townsend, Richard F., *The Aztecs*, London 1992

Vaillant, George C., *Aztecs of Mexico: Origin, Rise and Fall of the Aztec Nation* (revised by Suzannah B. Vaillant), Harmondsworth 1978

Vogt, Evon Z. *et al*, *Handbook of Middle American Indians* (7–8), Ethnology (1–2), Austin 1969

Warman, Arturo, *La danza de moros y cristianos*, Mexico City 1972

Williams García, Roberto, *Fiestas de la Santa Cruz en Zitlala*, Mexico City 1974